Sketches of KOREA

Sketches of Korea
An Illustrated Guide to Korean Culture

Written by Benjamin Joinau
Illustrated by Elodie Dornand de Rouville

Published in 2015 by Seoul Selection U.S.A., Inc.
4199 Campus Dr., Suite 550, Irvine, CA 92612, USA
Phone: 949-509-6584 Fax: 949-509-6599
Email: publisher@seoulselection.com
Website: www.seoulselection.com

ISBN: 978-1-62412-033-6 52200

Printed in the Republic of Korea

Benjamin Joinau Elodie Dornand de Rouville

Sketches of
KOREA
An Illustrated Guide to
Korean Culture

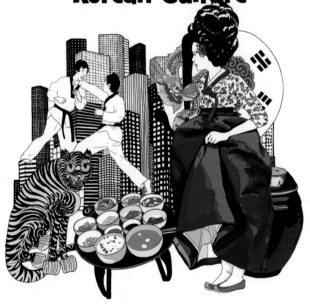

Seoul Selection

Contents

Introduction 7

Social

Ages of Life and Social Stereotypes 10
Body Language and Salutations 14
Table Setting and Etiquette 18
Markets and Street Vendors 21
Sleeping in Korea 24
Public Baths 28
Modern Housing Styles 32
Wedding and Marriage 38
Funeral Rituals and Ceremonies 42
City Signs and Symbols 45
Everyday Modern Objects 50

Cultural

Dishes of Korean Cuisine 56
Pojangmacha and Street Snacks 60
Kimchi 64
Jangdokdae 69
Drinking Culture 72
Festivals and Holidays 77
National Symbols 80
Games 85
The Korean Alphabet, Hangeul 90
Royal Shrine Ancestral Ritual 94

Artistic

Calligraphy	100
Ceramics	104
Dances	109
Colors and Patterns	113
Musical Instruments	116
Songs	120
Scholar and Court Paintings	123
Folk Paintings	128

Traditional

Women's Costume	134
Men's Costume	138
Men's Hats	142
Martial Arts	146
Everyday Objects of the Old Days	150
House	154
Gentlemen's Quarter	158
Furniture	160
Palaces, Fortresses and Gardens	164

Spiritual

Religions	170
Shamanism	175
Divination and Geomancy	178
Folk Beliefs	182
Buddhist Temples	186
Statues of Buddha	190
Buddha's Birthday	194
Supernatural Beings	197
Royal Tombs	202
Index	206

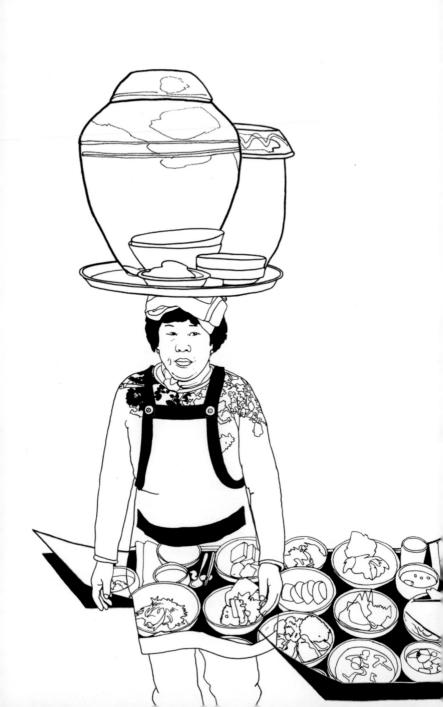

Introduction

We live in a world that is dominated by vision. Iconic representations, images, logos and videos flow incessantly around us. South Korea in particular is one of these "empires of signs" where a visitor can easily be overwhelmed. Moreover, Korean culture, although more and more appealing thanks to the Korean Wave, is still largely unknown in many regions of the world. How does one navigate their way in such a rich and vibrant culture?

Elodie and I have been living here quite a long time, and we have seen many very good attempts at providing cultural guides for foreigners who find themselves interested in Korean culture. Many of these works were state-sponsored publications and sometimes had the tendency to propose a "polished" and official version of the country's national icons. Others were in-depth in their portrayal of Korean culture, but lacked the visual and practical dimensions needed by newcomers

and amateurs.

When making this book, we especially wanted to broaden the scope of Korean "images" beyond the usual historical portrait of "cultural heritage" and include everyday life and modern elements that one inevitably encounter when visiting the country. Our aim is to present a more comprehensive notion of culture, one that encompasses both past and modern uses of the old symbols, as well as the society's actual contemporary practices.

We wanted to offer this book in a convenient format with a detailed index so that it could not only serve as a cultural guide, a vade mecum to bring everywhere while in Korea, but also as a resource that could be used at home by any person or student curious about Korea.

We hope it will be both useful and enjoyable as you find your way in Korean culture.

* Note: In this book, Korea is used to designate the Republic of Korea (South Korea).

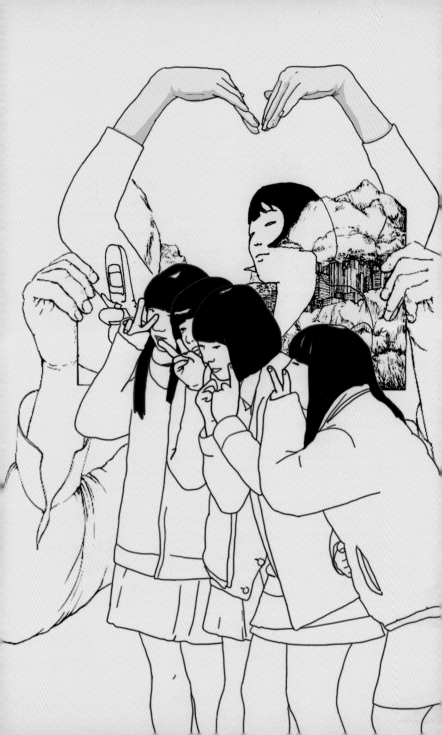

Social

Ages of Life and Social Stereotypes

Ajumma, ajeossi, haksaeng, hyeong, nuna, halmeoni . . .
Age differences are very important in Korean society,
used as a way to locate one's position in relation to one
another, decide how to address someone else, etc. Each
period of a person's life has a term that comes along with an
array of social stereotypes, which are made up of expectations,
roles, attitudes, uniforms and celebrations, among other things.
Here is a very simplified introduction!

In Korea, new babies are considered to be 1 year
old at birth, since we take into account the
intrauterine months of the fetus. He or she is
said to be safe after 100 days of ordinary
life, but nowadays the **baegil** 백일 (100th
day) celebration has become less
common, with more focus is given to
the *dol*, or the first year birthday, when
the infant is the hero of a big party.
At this party, he or she will be asked to
choose among different objects (paintbrush, money,
etc.) to forecast his or her future profession.

The adorable preschoolers in the streets? **Yuchiwon** 유치원, or kindergarten students.
Many young children attending the same school will wear some sort of matching
ensemble, whether it's a full uniform or simply the same t-shirts or backpacks.
This practice is less
common once they start
elementary school, but
uniforms become the norm
once again after they reach
middle or high school.

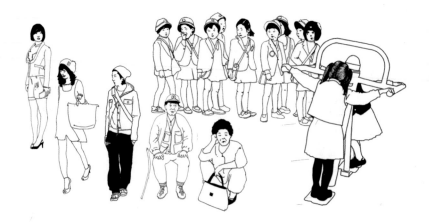

University students try to set themselves free from parents and school rule, but it is hard to resist the uniformization of lifestyles; just like their counterparts in the West, many can be found in baseball hats, street wear and sneakers. This is the ubiquitous look of the average **daehaksaeng** 대학생, or university student, although individuality is growing to be more valued, with some students daring to get tattoos and piercings, which in the past have been predominantly taboo. The new generation of students are high technology consumers: smartphone obsessed, addicted to social networks and chatting services like KakaoTalk, and they have developed their own online dialect. Despite their attempts to live in a virtual world, reality is sometimes harsh for them, since they are often desperate job seekers in a highly saturated market. Perhaps this is why they are some of the world's largest consumers of soju (see "Drinking Culture" on p. 72), and even share a very high suicide rate?

Some thirtysomething young professionals are opting to still stay single longer, leading them to cultivate their appearance more attentively than previous generations. This is the metrosexual era, with **kkotminam**, or "flower handsome" men—those who, while still being conventionally attractive, are not overtly masculine, and are comfortable spending their money on personal grooming. Their target? The brunch-eating, trend-leading busy women who are disciples of "Sex and the City" or latest US TV series heroines. These new generation girls value tall men, and despite the fact that they want more sensitive

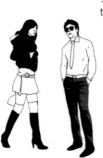

boyfriends, they also want them to be virile. More than the physically perfect *kkotminam*, they now tend to prefer *hunnam*, men who are charming and attractive, but not necessarily handsome. Some of the young ladies mentioned above have become obsessed with plastic surgery, allowing them to have a chance at seducing the opposite sex even if they aren't young anymore; in Korea, cougars are trendy! According to sources like *The Economist*, in 2012 Korea was the country in the world where people resorted to plastic surgery the most, with an average of 16 people out of 1,000 going under the knife. In Seoul, as many as 20 percent of women are said to have had such a procedure.

But they have to hurry up and find the appropriate mate. Once married or of a certain age, women will be called ***ajumma*** 아줌마, a generic term that roughly translates as "distant aunt." (Some refer to these women with malice as the "third sex"!) They don't have to seduce anymore, so they look for comfort—permed hair, huge skin-protecting sun shades, loose-fitting clothes—but they are also warm hearted and hardworking, and their apparent toughness is a consequence of their central role in a very competitive society. It should be noted, however, that *ajumma* has a low- and middle-class connotation, and is not a proper way to address a white collar or upper-class married woman (*samonim*). Just as middle-aged women are known as *ajummas*, their counterparts, middle-aged men, are known as ***ajeossi*** 아저씨; this word bears the same overtones of class and somehow "boldness." The salary men are referred as *hoesawon*, and they dress similarly to male office workers in the West: suits, ties and button-down shirts.

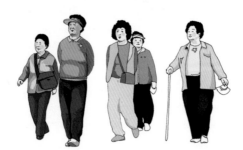

One day, with their back broken by the kimchi making sessions and all the children and grandchildren worn on their back, *ajummas* will become **halmeoni** 할머니, or grand-mothers. It is still a tradition to celebrate the 60th birthday as the completion of the lunar life cycle, *hwangap*. Though, with life expectancy rising, it is becoming more common to celebrate it at 70. As for the men, they become **harabeoji** 할아버지, or grandfathers, and they also, of course, celebrate *hwangap*, their 60th birthday. Like many *ajeossi*, they enjoy doing *deungsan,* or mountain climbing, and it's not uncommon to see them wearing brand-name hiking gear from head to toe, even for a short stroll!

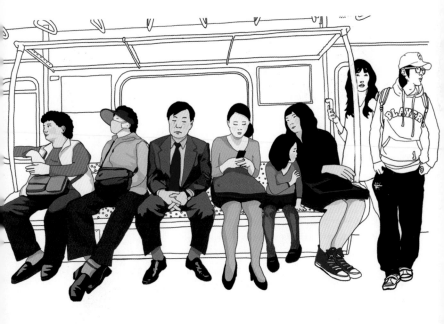

Body Language and Salutations

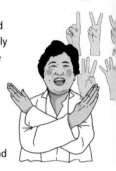

In Korea, one has to be quite careful of the attitude portrayed by one's physical posture and gestures, since it has been strictly codified by centuries of Confucianism. A proper attitude in the right situation is expected, and you have to be aware of what you are doing with whom, and when. It can be quite complicated, so don't try to get all the subtleties at once; just try to observe what people do, and follow some of the basic rules explained here. Salutation protocol in particular is very important if you are meeting Koreans in a formal situation. And don't forget that this can all be flipped upside down after few drinks! We also introduce more modern, casual and fun gestures.

Making a heart over the head with two arms

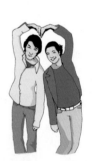

Mimic of love for two

Look at her, how pretty she is! When a person holds their closed fists on their cheeks, it expresses jokingly that the person doing the action wants to be seen as cute and nice. Being lovely and smiling is a very valued attitude in Korea, at least for women or younger men, so save your cynical face for home!

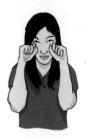

Two fingers up above your forehead, like two horns: the image is clear, you are angry! In the Chinese cultural sphere, there are some who believe that teeth have an erotic connotation. Perhaps this is why, traditionally, it is not polite in public, especially for women, to display teeth in a large, opened smile? These days, one should still cover one's mouth shyly with one hand when laughing or smiling.

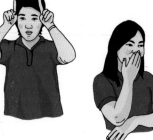

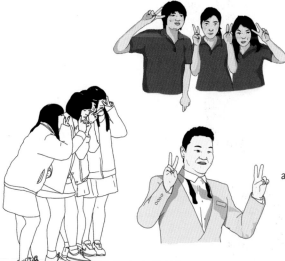

V for Victory, a sign which is said to have been brought by the American troops at the liberation from Japan or during the Korean War. It has since become the all-purpose hand gesture for Korean photo ops.

This doesn't mean Zero, but "money," though Western influence means it has also taken on the meaning of "okay."

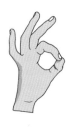

Observe the position of the arm and the hand's specific gesture. The palm should face the ground and be moved down and inward when you call a taxi or want to ask someone to come toward you. Never use your finger to call someone or taxi to come toward you.

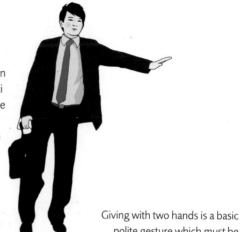

Giving with two hands is a basic polite gesture which *must* be followed when interacting with Korean people. You never give or take anything—objects, food, drinks, even your own hand for handshaking—without observing this gesture; the hand which is going to offer or receive is always accompanied by the other one. The position of the second, inactive hand, whether at the wrist or below the armpit, depends on the level of formalization and respect you want to show the recipient of the act. If you want to be extremely polite, you can give or receive with both hands together while bowing.

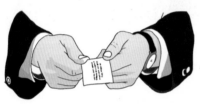

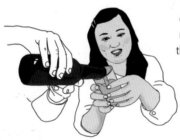

This is especially true in a drinking party when accepting a glass of alcohol from a superior. While holding the glass with two hands, you turn your head slightly away, so that you don't face him or her when drinking.

Salutations

Handshaking: This Western gesture is typically used by men when either meeting someone for the first time or seeing someone after a long absence. Korean people do, however, like to take the hands of someone that they are happy to see between their own two hands. Depending on the situation, body contact can be very important in communication in Korea, but kissing in public, and even hugging, is frowned upon.

Normal bow: This is the regular way to salute when meeting, parting or thanking someone. For the regular bow to be complete, both hands should be put together on the legs. Depending on the formality of the situation, you are supposed to lower your body more or less. For a nice bow, your face should be facing the ground—don't try to look in the other's eyes. Unlike the West, where prolonged eye contact is a sign of respect when talking, with elders in Korea, it is considered impolite.

Deep bow (*jeol*) is used for special occasions: in front of respected elders, during ceremonies such as weddings and funerals and on special holidays like Chuseok and especially Seollal—then called *sebae*.

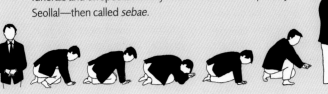

Table Setting and Etiquette

A famous French food critic has pegged Korean food as the next big thing in world cuisine. Keeping this assessment in mind, it's time to learn the basics, which start with the structure of meals and the proper way to enjoy them.

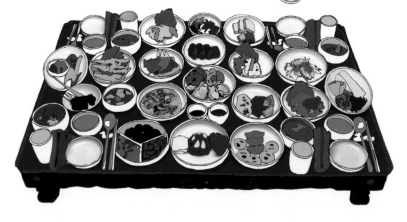

The Korean table revolves around the rice (**bap** 밥). Any basic meal in Korea is centered around rice if it's available, though it is sometimes replaced by barley (*bori*) or grains mixed with white rice (*ogokbap*, for example), or even by noodles (*guksu*). Add a soup (**guk** 국) and side dishes (**banchan** 반찬), and you have the regular Korean *siksa*, or meal. Add more side dishes and it can become a *hanjeongsik* (as seen in the large illustration above showing a variety of side dishes served together, a tradition famous in the Jeolla region), or even a *sura* (royal table)! In some restaurants, *hanjeongsik* is served in courses, Western-style, while in other restaurants, it's served all at once in the Korean traditional way. Some dishes are sometimes eaten as "starters" before the rice and soup, such as grilled meat.

The basic table setting, or *sangcharim*, is based on the structure found on the individual small tables called **soban** 소반 (or *sang*, or *bapsang*) and in the past was typically only used by adult males. Rather than eating at the same table, women and children had a table of their own or would eat in a different room altogether. Rice or cereal are placed on the left, soup in the middle, spoon (**sutgarak** 숟가락) and chopsticks (**jeotgarak** 젓가락) on the right and some side dishes, or *banchan*, in the front.

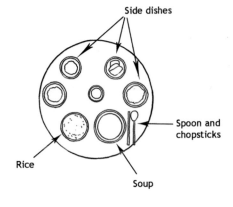

Side dishes

Spoon and chopsticks

Rice

Soup

The side dishes (also called *cheop*) were served in odd numbers (3, 5, 7, etc.), giving the name of these *sangcharim* (3-*cheop*, 5-*cheop*, etc.). It is only with the 20th century that the table became bigger and gathered the whole family. By then, some of the side dishes started to be developed as main dishes served in the middle of the table to be shared.

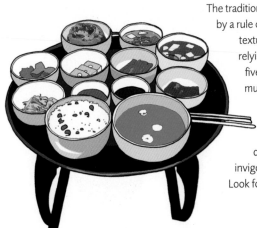

The traditional *sangcharim* is structured by a rule of harmony between colors, textures, tastes and ingredients, relying on the *obang ohaeng*, or five elements theory. The food must not only be palatable and pretty, but also healthy. This is a central concept in the Korean diet; each dish and drink has supposed invigorating or curing properties. Look for the many "stamina" foods favored by men!

Etiquette

The basic rules are simple. Don't clean your nose when at the table. You should allow elders to eat first. Never drink by yourself; wait to be served and to be invited to drink, usually with a toast. Don't forget to serve the elders when their glass is empty. Don't plant your chopsticks in food, especially the rice: This is how incense is presented during funerals. Try to avoid eating the rice with your chopsticks.

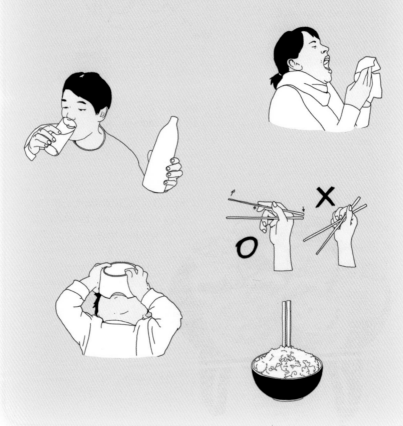

Markets and Street Vendors

Like anywhere else in the an open museum where you products, authentic food treasures region. And like all markets in specializalties and abundances, items and rows of shops lined But the display is not limited there are also a lot of street to you with their cart or truck world, Korean markets are can go and discover the local and the atmosphere of the Asia, depending on local you'll find piles of colorful with similar products. to the official markets; vendors coming directly of goods.

The most famous markets in Seoul are **Namdaemun Market**, located close to the South Gate, and **Dongdaemun Market**, which is found in the vicinity of the East Gate and **Cheonggyecheon Stream**. The former is a semi-traditional market where you can find almost anything. The latter, however, is actually a series of smaller districts: The market specializes in cloth and fabrics, though also features antiques, used appliances and other household goods, and the list goes on. Regardless of what's available, make note of the fact that sale prices are not labelled on the products, so feel free to bargain!

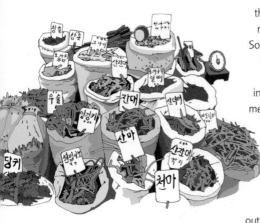

Besides these well-known places, there are also a lot of other interesting markets located in and around Seoul. Some are more specialized, such as the **Gyeongdong Market** in Jegi-dong. There you'll find all the herbs and ingredients for your Korean traditional medicine: deer antlers, dried toads and caterpillars, powders and rare wood barks—it really is a feast for the eyes. Other older and typical markets include the Jungang Market in central Seoul or the Moran Market on the southern outskirts of the city, the latter having the air of a farmers' market.

There are also wholesale markets like the huge **Garak Market** in southeastern Seoul, which is thankfully open to retail customers as well. For seafood, the biggest draw in Seoul is the **Noryangjin Market**, but the model for all fish markets in Korea is the **Jagalchi Market** in Busan. In these markets, you can have your pick of live seafood and have it prepared to your liking on the spot.

But market life isn't limited to buildings or specific city blocks. There still are a lot of regular itinerant markets in the countryside, most of them called **oiljang** (five-day market) because they are held every five days. Among them, Jeongseon *oiljang* in Gangwon region is famous for its authenticity. You can find farmers' products sold directly off the floor in the streets of the marketplace, with plenty of food stalls offering delicious local fare.

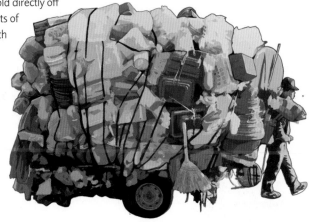

Let's not forget the numerous sellers who come directly to your street or neighborhood. First of all are the ubiquitous *yakurt ajummas*, who sell and deliver dairy products with their yellowish uniforms and carts. Noisier, however, are the trucks that come to sell vegetables, fish or household commodities with their shouting microphones during the day; they are replaced at night by the disappearing sellers of glutinous rice cakes (*chapssaltteok*) and their melancholy calls of "*Chapssaltteok!*" as they promote their goods. Both are becoming scarcer as large shopping centers become more prevalent.

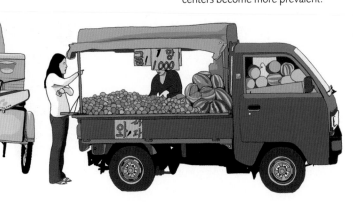

Sleeping in Korea

Sleeping in Korea is often a distinct cultural experience in itself for Westerners, particularly those not accustomed to sleeping on the floor. Korean people traditionally sleep on a very thin futon, but nowadays they favor beds as well. From the traditional guesthouses set in *hanok* to the infamous love hotels, from the fancy pensions in the countryside to the 5-star suites, here are some explanations for where to lay your head at night in Korea.

Minbak

Among the many types of hotels in Korea, the most simple is the *minbak* 민박, or home stay. Always found in the countryside, *minbak* are set in people's houses where a room is rented along with access to a shared bathroom. It can be a great experience or just a Spartan accommodation for low budget travelers. Though *minbak* are starting to disappear, some fancy *minbak* still call themselves "*minbak*" for legal reasons, but have all the comfort of a pension.

Hanok guesthouse

One of the newcomers, *hanok* guesthouses are mainly found in Seoul, Jeonju and Gyeongju. Technically, these are really just *minbak* set in more traditional houses, or **hanok** 한옥, though the welcoming atmosphere found in such places is on par with what international visitors might expect from a guesthouse.

Hot Floors for Beds

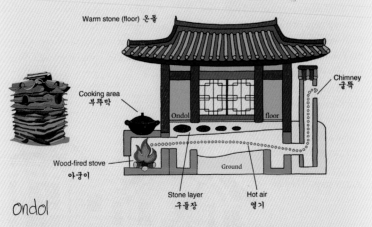

Warm stone (floor) 온돌

Chimney 굴뚝

Cooking area 부뚜막

Ondol floor

Wood-fired stove 아궁이

Ground

Stone layer 구들장

Hot air 열기

Ondol

Ondol 온돌 is the Korean version of the hypocaust (underground heating system) said to have been developed in the Three Kingdoms era (the fourth century through the seventh century). Air heated in the outdoor kitchen fireplace (*agungi*) runs under the floor, warming up the rooms before exiting through a chimney in the back of the house. The floor is covered with oiled paper to prevent smoke from leaking. Nowadays, the air has been replaced by water heated via a boiler and running through the house in plastic or copper pipes.

Bedding

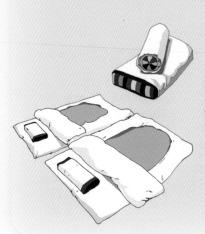

In Korea, people still sleep directly on the floor without a mattress or bedframe (even though the latter are now very common). This practice of resting on the floor allows the sleeper to enjoy the warmth of the *ondol* system directly, which can be burning hot in some places! People often use a thin mattress called a **yo** 요, sometimes as thin as a bed topper, kept rolled during the day in a closet and laid at night in the place that becomes the sleeping area. On top of this, Koreans use an **ibul** 이불, or blanket.

Pension

Pensions are quite a new addition to the accommodation scene, but are surely the most popular nowadays with the development of the leisure society. More specifically, the popularity of the five-day work week—which only became the legal standard in 2003—and the normalization of the weekend means that Koreans are freer to do things like take trips in their leisure time. With similar amenitites to the condominium, you can rent a pension for single nights as well as longer stays. They are usually more interesting for groups than individuals, since you sleep on the floor in a large room that comes equiped with a kitchen. Most of the time, pensions have patios featuring barbecues and, if you're lucky, sometimes swimming pools.

Condominium

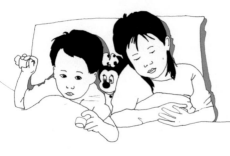

Condominium is the word used to describe time-share apartments. Equipped with a kitchenette, they are the perfect way to feel at home when you're on vacation, combined with the service of a hotel. You don't always need to have a membership, but reservations are still a requirement.

Yeogwan

This is the Korean word for Japanese *ryokan*, but has nothing to compare with its Japanese counterpart, except the gloominess you can find in old, run-down places. It is no more, or less, than a motel, and although some of them are really improving their amenities due

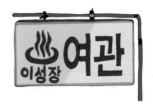

to competition in large cities, many in the country still offer simple, bland, dirty rooms with *yo* and *ibul*. Most of them, however, offer rooms with beds. You can recognize them from the street because of the flame symbol, meaning hot water (like on the signboards of saunas). One category that has almost vanished is the *yeoinsuk*, a middle ground between *yeogwan* and *minbak*, but don't shed any tears—they were really austere and filthy accommodations.

Motels and love hotels

A motel or love hotel is the modern incarnation of the *yeogwan*, and sometimes refers to the exact same type of accommodation. They are now available in cities (everywhere!), typically very well furbished (Internet, large TV, DVD player) and are often decently priced alternatives to hotels. Most of them serve as "love hotels"—places for lovers who rent a room for few hours only. Contrary to what one might think, they aren't unseemly places to visit, since each offers clean sheets and rooms, and most of the lovers are young couples without places to go (for some Koreans, this is even an accepted part of the dating ritual!); these motels are not necessarily linked to prostitution, and are actually quite safe to visit.

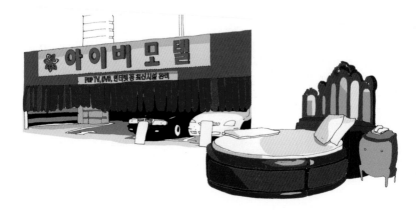

Public Baths

Public bath houses are still very popular in Korea, even if all homes come fitted with a bathroom nowadays and many have their own tubs. The bath house is a social place where friends, colleagues and families gather and spend time to relax, sometimes to get rid of a hangover, even! For middle-aged women, it is still a place to exchange local news and gossip. Men and women share some areas in the *jjimjilbang*, but not the bathing area where nudity is compulsory. There are also saunas and *jjimjilbang* that cater exclusively to women. The bath house experience is an absolute must while in Korea. Since many places are open around the clock and feature rest areas (*hyugesil*) sometimes equipped with futons and blankets, many backpackers (or late party goers) use them as a cheap alternative to a hotel stay.

Mogyoktang 목욕탕

Upon arrival, you will first pay at the counter, where an attendant will sometimes ask you to leave your shoes in a small locker near the front desk. Next, you receive a key for a larger clothing locker in one of the gender-segregated change rooms; if they don't give you a key, just enter the changing area, take out your shoes and put all your clothes in one of the spaces provided. Keep the key strap on your wrist or ankle, and pick up one of the towels as you enter the bath area. Soap is provided, shampoo not always. You can buy it along with razors, scrubbing gloves (very popular, often green), tooth brushes, socks and underwear at the counter or in automatic dispensers.

Always take a shower before entering the bath or sauna. The rooms will be divided according to their temperature or purpose, and patrons are expected

to gradually saunter from room to room over the course of their time there. The regular order is to do the warm bath first, then the (very!) hot bath, then on to the sauna (there are sometimes a variety of them, from dry to steam saunas, and also loess, charcoal, herbal and a lot of themed heated rooms) and finally, if you are courageous and in good health, a dive into the cold bath. You then repeat this cycle until you feel regenerated!

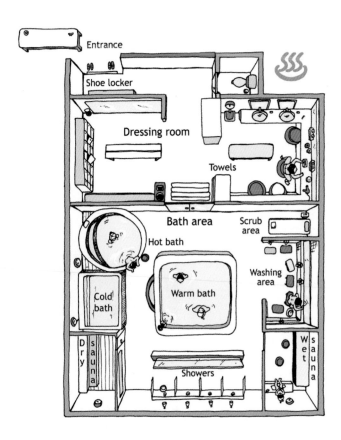

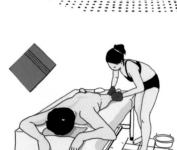

After the bath, you can go to the washing area where you'll find low stools in front of a mirror and a low shower to wash yourself thoroughly, shave, etc. You can enjoy the very special body scrub service (*ttaemiri*) in a corner of the bath area, which you pay for when leaving. The practice involves lying naked on a table and having friction applied to every inch of your body, so be prepared! You can also do it by yourself with the aforementioned green glove or towel (*ttaemiri tawol*). Look around and you'll notice that people often help each other with this, and you may have a stranger offer to scrub your back in exchange for doing theirs, which is a decent proposal.

Watch out for the *jueui sahang*, or information panels—they can sometimes give some pretty funny guidelines

• It is our culture to bathe naked.

• Please bathe sitting down, so you don't splash everybody around.

• Please wash your body before you get in the bathtub.

• Don't put your towel or wash your body in the bathtub.

• The bathtub is for soaking in only.

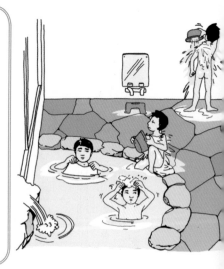

Oncheon 온천

Korea also boasts a fair number of hot spring complexes (*oncheon*). *Oncheons* operate using the exact same process as *mogyoktang*, but the water used is spring water extracted from underground and sometimes reheated. In the best ones, you'll find a lot of "event" baths, and even outdoor bathing areas (well-enclosed behind walls). Imagine yourself soaked in boiling hot medicinal water under the snow! At some of the hotels in these resorts, the tap water in the bathrooms also comes from the spring, so you can enjoy your "cure" in a private setting.

Jjimjilbang 찜질방

The last category, which is very popular in big cities, is the *jjimjilbang*, or sauna and bath complex, with floor-heated resting areas to lie down, relax and cure your aches. There are no limits to the type of amenities that may be on offer; some have *karaoke*, boutiques, restaurants, Internet cafés, electric massage chairs, sleeping areas, sports massage and beauty shops, cinema rooms—the possibilities are endless. Your key number is usually used to track which services you've used during your time there, and you pay as you leave the sauna. In these places, the bath areas are separated by genders, but both sexes can meet in the common resting areas wearing shorts and tee-shirts provided for free in the dressing room. *Jjimjilbangs* replaced the old *mogyoktang*, and are an important relaxation and leisure place for families and couples. They have become so important that they even serve as the sets for soap operas or TV shows!

A typical snack at one of these complexes are eggs cooked in the *bulgama*, or very hot "kiln-like" room, usually made of red soil (loess), where people specifically go to sweat. There are also a variety of "health" drinks like *misutgaru*, a mixture of roasted grains, available.

Modern Housing Styles

One can hardly avoid the housing issue in modern Korea; it's the central concern of most people's lives. When looking at the incredible vitality of the nation's construction industry, Korean housing is often a source of wonder, but that same industriousness can become a source of discomfort and occasionally repulsion when looking at the endless rows of concrete residence complexes called *apateu danji*. Despite the apparent homogenization, however, the scene is changing fast in large cities like Seoul, as well as in the countryside. Here are some clues about where modern Koreans live.

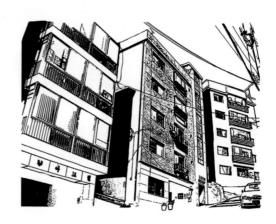

The apateu republic

The **apateu** 아파트 phenomenon started in the 1970s on the Hangang River. *Apateu* is the Korean word for apartment, and when **danji** 단지 is added, it represents a complex of such blocks. At the time when the towers first started being built, the common dwelling style was the modernized *hanok*, or Korean house, or an individual, Western-style house. There were already some residences or villas (described later) that featured multiple floors, but what made the *apateu* revolutionary was not its height, but its uniformization of lodgings and the initiation of the "compound" culture.

In Seoul, government used the *apateu* to encourage urbanization, moving famous schools to the newly developed areas south of the river, such as Gangnam. The new system took some time to be adopted, but once it took off, it became one of the most representative social movements of modern Korea. Still now, living in an *apateu* is looked at by most people as a sign of social achievement. Considered clean, safe and convenient, they are especially desirable as a long-term investment and a symbol of social status. As such, these near-identical uniformised housing units have a completely different signification in Korea than their counterparts in the West.

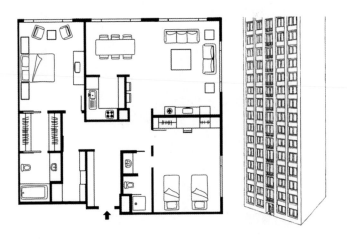

The villa

For those who can't live in an *apateu*, there are still a lot of areas filled with **billas** 빌라 (Korean for villa), or multi floored residences with a minimum of two families (often an owner and one or more tenants). Villas represent an older housing tradition in Korea. Originally, built with red bricks, villas sometimes also feature, as in this illustration, a traditional blue-tiled roof. Set in the small, maze-like alleys filled with nets of wires and vegetable or flower planters, kimchi pots clustered together on flat roofs or terraces, they retain some of the old-world atmosphere and community.

At times noisy, dark and insufficiently maintained, they are considered a temporary step toward obtaining an *apateu*.

There is a rental system that is very common across different housing styles, known as the **jeonse** 전세 system, meaning people deposit a relatively large amount of money to the house owner instead of paying a monthly rent (**wolse** 월세). The villas have tended to replace the individual houses that once dominated the market, as the allure of having more rentable space is seen as an obvious advantage for owners.

New style of towered apateu and multi purpose buildings

Up until the 1990s, the standard design for *apateu* neighborhoods was to have a large complex of numbered high-rise blocks (*dong*) set in rows. For Western eyes more accustomed to suburban sprawl, it made for an urban landscape that was deceptively depressing and uncharming overall. Since the 2000s, however, with new policies emerging with regards to real estate, the attitude toward the *apateu danji* has begun to change. The current trend involves smaller, more low-rising *danji* (like those that existed in the early 1970s), single or double towers (as opposed to the *apateu danji*, which often connected a multitude of buildings) and individualized designs,

at least on the outside. There is also a greater degree of effort put into landscape design in common spaces and other shared commodities. Externally, this shift has also resulted in a slight "decompoundization" of the *danji*, allowing them to be more open and integrated within the city, similar to the *jusang-bokhap*, or residence towers with offices and shops on the first floors.

The looming real estate bubble is changing things, however if the growing demand for upmarket "villa" residences is any indicator, there may be a shift toward more individualistic housing over the next few years.

While in the countryside

As incredible as it may sound, one can find the *apateu* system
even in the countryside, though the average country house or
farm is more akin to the villa mentioned before. Those who have
less means still dwell in the 1970s model farmhouse, fitted a
traditional earthen walled home with a metallic roof.

Painted in joyful colors (red, green, blue, orange), these
roof-styles are the legacy of the President Park Chung-hee's
"New Village Movement" (**Saemaeul Undong** 새마을운동), which
effectively banished the traditional thatched-roof houses
(***chogajib*** 초가집) from the country landscape. In the past, only the
richest residents could afford tiles (***giwa*** 기와) for their houses, but
this is no longer the case.

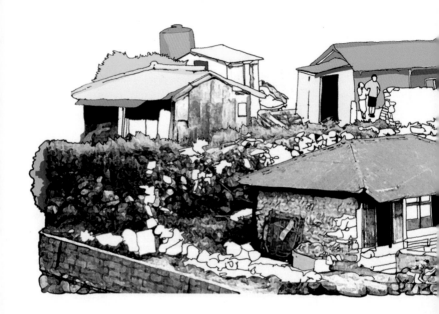

The rise of the leisure society is causing even further evolution among this already multifaceted countryside landscape: more and more pensions and small home-stay resorts have opened here and there, bringing in new architectural styles, from the American-inspired prefabricated house to the new *hanok*. A similar effect can be seen in the cities, where redevelopment is mostly implemented in shanty towns on hills called *daldongne*, or "moon villages," bringing out the best and, as it were, the worst of progress.

Wedding and Marriage

In spite of Korea's continued embrace of modernization, weddings remain a crucial life event that not only represent the expression of individual love, but also have a deep social significance. They have long been (and still are) a public union of two clans or families. Traditional wedding ceremonies are no longer widely performed (though they may be making a comeback as a trendy contemporary form, the alternative), but even in their structure and elements of the the older practices are still present.

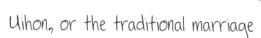

Uihon, or the traditional marriage

The old traditional marriage was a long process; in addition to the ceremony itself, couples also took on a series of obligations both before and after the main event. Everything started with the service of a matchmaker who would find the right bride (**sinbu** 신부) for the right groom (**sillang** 신랑). A suitable match meant not only proper social background, but also a strong astrological pairing: the year, month, day and hour of birth (*saju*) had to be examined by a specialist, a process called *gunghap*. After the details of the *saju* were exchanged and

deemed acceptable to the matchmaker, the union was considered to be officially confirmed, and an auspicious day was fixed for the ceremony (*taegil*).

The groom then visited the bride's family with gifts (in the old days, pieces of fabric and two wooden geese, or *mogan*, symbolizing union until death). The gifts, or *yemul*, were brought to the family in a wooden chest called a *ham* and held by a servant or, nowadays, the groom's best friend. After this visit, the wedding ceremony was held few days later at the bride's house and expense.

38

Daerye, or the traditional wedding ceremony

The *daerye*, or wedding ceremony, consisted of mutual and formal salutations by the bride and groom placed on each side of a ceremonial table (*honryesang*). On the table, among other things, there were branches from a pine tree and bamboo plant that symbolized fidelity, a fistful of Korean dates to represent the bearing of sons and a hen and chicken on each side that signified fecundity and the expulsion of evil spirits, respectively.

After an exchange of rice wine cups and the release of the chickens, the couple was then considered married and the feast could start for the relatives and friends invited. The couple used to stay three days in a new room (*sinbang*) at the bride's house before leaving forever for the groom's house (*sinhaeng*). The woman rode a palanquin (*gama*) and the man atop a horse. Upon arrival at her new residence, the newly-wed wife participated in a *pyebaek* ceremony as a means of gaining acceptance from her new in-laws: The woman, wearing three red dots on her face as symbols of her humility, had to perform deep bows (*keunjeol*) to her husband's parents, helped with this difficult task by one or two other women. Modern couples, who would like a more traditional wedding, may still incorporate some of these practices into a contemporary ceremony.

The traditional wedding costume

Since the Joseon era, a wedding was one of the few occasions where even commoners were allowed to wear the colorful and fine outfits usually reserved for court people. The man would wear a *gwanbok*, or official uniform, usually deep blue or violet in color. The woman, by contrast, would wear a *hwarot*, or court lady dress, with the *jokduri* ornamental crown held by the long *binyeo*, or hairpin.

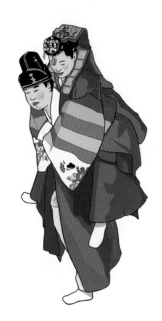

The modern style marriage

Although matchmakers and arranged marriages have been gradually disappearing, using blind dates to find one's spouse and *gunghap* to confirm her/his astrological suitability are still common. Once an engagement is confirmed, one of the first steps is to have the wedding pictures taken.

In the past, this may have been carried out in a public park or palace, though it is now more normal to have them done in a studio with a professional photographer, or out at some other location chosen by the couple. Sometimes the *nappye*, or ceremony of bringing the gifts to the bride, is still performed, as well as a bachelor party. In most cases, the wedding ceremony, or **gyeolhonsik** 결혼식, is performed in a wedding hall (**gyeolhonsikjang** 결혼식장): The couple arrives dressed in a Western-style dress and tuxedo before proceeding to a stage where a master of ceremonies (*jurye*)—an influential friend of the family, professor, priest or pastor—gives a speech. After the couple is announced by the *jurye*, the two people are considered married, at which point it is time for group pictures. In the meantime, the guests, often numbering in the hundreds, enjoy a quick meal. In most of cases, the couple then retires to a private room to perform the *pyebaek* ceremony in traditional clothes with the closest relatives only. They will often leave for their honeymoon trip immediately, dressed in the same outfit to symbolize their unity as a couple. At this kind of modern party, don't forget to leave an envelope at the entrance with your name on it filled with money, an offering to help the families cope with the huge expenses from the event.

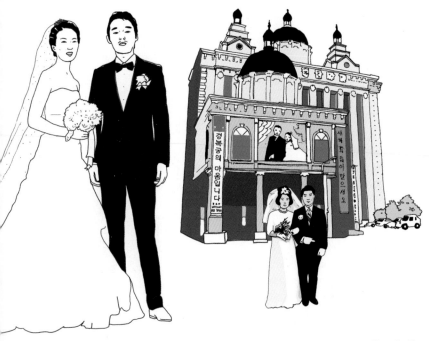

Funeral Rituals and Ceremonies

Funeral ceremonies and rituals have a very important role in Korean society, and have remained highly codified, even in modern times. The rites are still practiced on a regular basis, even though young, urban generations and Christians especially (who consider them as paganism) have tended to abandon funeral ceremonies in their traditional form. These customs reflect the Confucianist ideology where respect to the elders and ancestors is upheld to the highest degree. Besides the funeral ceremony itself, called *jangnye* (or *jangnyesik*), special memorial rituals (*jesa*) are held on special occasions throughout the year.

Jangnye 장례

A Korean traditional funeral is usually three days long. The body of the deceased is placed in a coffin and presented in his or her house, though nowadays more and more funerals are taking place in special hospital wings called *jangnyesikjang*. A memorial tablet where the soul comes to rest is set on a table in front, along with large, standing wreaths and incense sticks. The mourners, dressed in specific clothing (described later), wait here to receive the condolences of relatives and friends. After two days and nights, the coffin is set in a funeral bier to be brought to the tomb (**mudeom**, or **sanso**) as part of a procession.

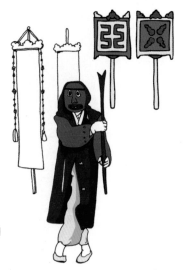

The *sangyeo*, or traditional funeral bier, is a bright and very decorated cart brought by four to eight people. The procession, called a *haengyeo*, is by long banners (*myeongjeong*) with the name and status or position of the dead person written on it, and other flags. A cart is also brought with the *sinju*, or the deceased person's tablets, which are now more often replaced by a picture. The *sinju* are brought back home after the burial for the ancestral rites. Nowadays these processions are rare, and when the burial takes place on a mountain, private buses are used to carry the body and relatives to the *sanso*.

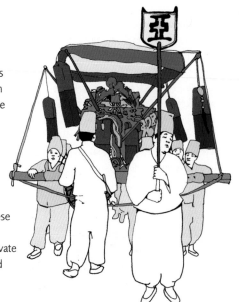

Mourning

Relatives up to the eighth kin are expected to wear the mourning clothes. To show the purity of their grief and respect to the dead person, Korean men would traditionally dress in a special outfit called *sangbok* 상복 made of white hemp cloth. There were special items such as the white conical hat (*gulgeon*), which are still worn by direct descendants in addition to the Western suit. The outfit for women is simpler, made of white hemp cloth.

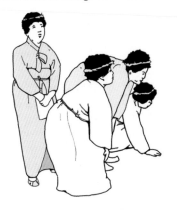

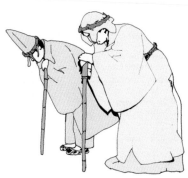

In modern Korea, it is no longer realistic for the family to stay in mourning for the full three-year period; the bereaved family is now usually in full mourning for three days. During this time, women usually wear black or white clothing while men just wear a piece of white hemp on the arm of their dark suit at funeral ceremonies only. After that time, special memorial ceremonies are performed a few times a year and can take place up to four or five generations after a person's death.

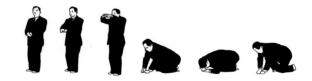

Jesa 제사

Ancestral rites are called *jesa*. They include the most common, *charye*, offered to the spirits of the deceased relatives on Chuseok, Seollal (Lunar New Year) and, in the past, at Hansik festivals. Other ceremonies include *gije* at the anniversary of the ancestor's death and *myoje* and *sije*, which are held at the grave. At these rituals, *keunjeol*, or deep bows, are always performed twice, followed by a light bow.

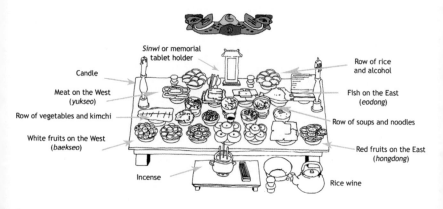

Sinwi or memorial tablet holder

Candle

Meat on the West (*yukseo*)

Row of vegetables and kimchi

White fruits on the West (*baekseo*)

Incense

Row of rice and alcohol

Fish on the East (*eodong*)

Row of soups and noodles

Red fruits on the East (*hongdong*)

Rice wine

City Signs and Symbols

Let's stroll around the streets of a large city and pick some random sights. The country is actually a real "empire of signs," isn't it? Here are some clues to decode urban signage in Korea.

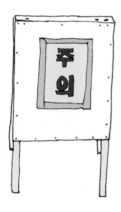

This sign is used when there is construction work in progress nearby. *Jueui* 주의 means "be careful," "watch out."

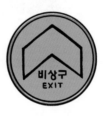

The sign says *bisanggu* 비상구 for emergency exits.

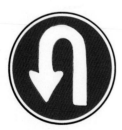

For those unfamiliar with this traffic sign, it means a "U-turn" is possible.

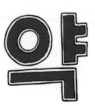

This sign is very useful and posted in front of most pharmacies. *Yak* 약 means medicine.

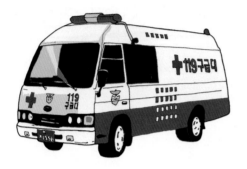

This is an **ambulance,** with a green cross and the very useful 119 number to call in case of an emergency.

The **Korean address system** can be puzzling, and it can sometimes be difficult to find your destination if you look at the building number alone. City addresses typically start with the *gu* (district), then give the *dong* (area), followed by *beonji* (building number). But there is a new address system that is slowly being adopted: above is an example of a number with the new street name. To find your way in apartment complex, or *apateu danji*, look on the side of the building: you'll see the name and the tower number.

On the left is a red **mailbox** from the Korean post office. Don't get them confused with the green or yellow boxes, which are used for clothing donations!

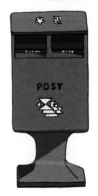

On the right you will see the stands displaying free magazines in front of subway entrances, and on the left the bags hung on door handles are used to deliver the daily newspapers or milk and yogurt.

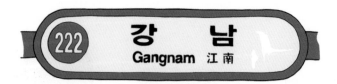

222 | 강　남
Gangnam 江南

You see here an example of a **subway station** sign with the name and number of the station and the color of the line.

This seat is for handicapped people, the elderly and pregnant women.

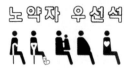

노약자 우선석

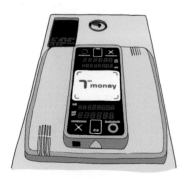

Taking the subway is convenient.Korea doesn't have tickets anymore, so frequent users have rechargeable T-money cards (you can buy them at convenience stores, and they work for subways, buses, taxis and even in some shops). For a single trip, however, you can buy a card at the automatic dispenser. Don't forget to get the 500 won refund outside the exit!

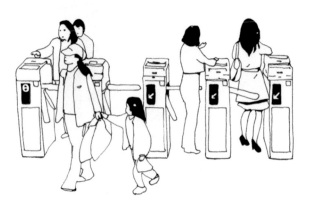

This is the entrance/ exit of the subway, the place to put your refundable card.

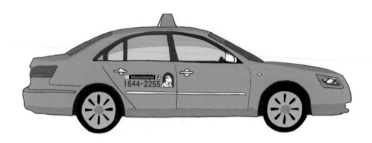

Taxis are now orange in Seoul (some being "international," meaning that they have services to assist you getting to and from the airport and to common tourist sites—but don't expect English fluency!), while the deluxe taxis (*mobeom*) are black.

Podori is the police mascot character. Don't be afraid, he's here to help you!

This **haechi** is the new mascot of Seoul. See the "Supernatural beings" section (on p.197) for more info about its symbolism.

Everyday Modern Objects

Many societies have established museums as a way to recognize the everyday objects used by people of bygone eras. But what about the thousands of items we still use on a daily basis that we don't even notice anymore? We simply ignore them, despite their being a significant part of our lives and imaginations. Let one disappear and we mourn it with nostalgia . . . "Ah, do you remember when we were young, when we used to have the . . . ?" So before they are discarded, here are few very Korean objects that you'll see and use a lot. Don't look down on them—they're a part of our modern identity!

Mokjanggap

All-purpose gloves would appear to be a rather universal object, right? But the way they are used in Korea is really specific; you'll see workers wearing the red rubber–coated ones for their anti-slip, waterproof qualities, but the immaculate, white version is also used by police, department store clerks, mourners and people acting in all kinds of official situations.

Ingam dojang

This object is used by every Korean in place of a signature. The seal, or *dojang* 도장, can be carved into a variety of hard materials, such as wood, stone or jade; when officially registered, it is called *ingam dojang* 인감도장. To print the mark representing the calligraphied name of the user, one uses red ink, or *inju*.

Ttaemiri towel

This colorful piece of cloth is found in all the
public baths and in most bathrooms throughout
Korea. Called *ttaemiri* towel 때미리타월 (scrubbing
towel) or *itaeri* towel (the special fabric was
supposedly brought from Italy), it is used to
scrub the dead skin off one's body.

Jige

We will be discussing the
term *jige* 지게, or traditional
A-frame rack once used by
laborers, later on in this
book. Here, we refer to the
modern version, which is
typically installed on
motorbikes to deliver
mountains of items across
cities at high speed.

Visors

If you don't know exactly who can be designated by
the term "*ajumma,*" or middle-aged woman, watch
out for this particular item. They have the appearance
of a brimmed visor, but it can also be used as an
eyeshade when lowered on the face like a mask. It
protects not only the eyes, but also the fairness of the
skin from the bright Korean sunlight.

Slippers

Where you're from, slippers might just be slippers, but that's not the case in Korea, where they are much more than simply comfortable shoes used in the privacy of your home. Since it is a common practice to take off your shoes in most spaces because of the custom of sitting on the floor, slippers are seen literally everywhere, even in offices. Their widespread use outside the home shows a really different approach to the separation between private and public spaces.

How to use Podaegi

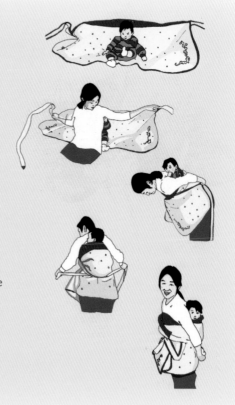

You'll probably hear the famous joke about that woman who was looking desperately for hours for her child only to realize that he was in her back, comfortably sleeping in his *podaegi* 포대기. This item is a very useful way to carry the babies, keeping mother and child close to one another in a comfortable setup while leaving the mother freer to go about her own business.

Hyojason

This strange device is called the "dutiful
son's hand" because you use it to
scratch your back, something that the
ideal Confucian son would do for you, if
you are able to track one down.

Smartphones

This ubiquitous and versatile cellphone is gaining popularity all
over the world, but in Korea they have become the standard for
nearly everyone from children in primary schools to grandmas in
country markets. Called "handphone" in Konglish and **hyudaepon** 휴대폰
in Korean, the newest technological improvements permit their use as
computers, personal organizers, DMB TVs, video game consoles,
Internet browsers and MP3 players, among an array of other uses via apps. A
quick ride on the subway will demonsrate how indispensable they have
become to riders killing time in the subway, either by sending *munja*
message (SMS) on KakaoTalk or watching one's favorite drama. It would not
be outrageous to suggest that Korea possess one of the most smartphone-
and tablet-savvy populations in the world.

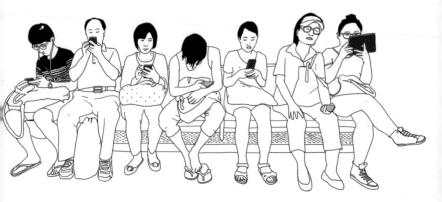

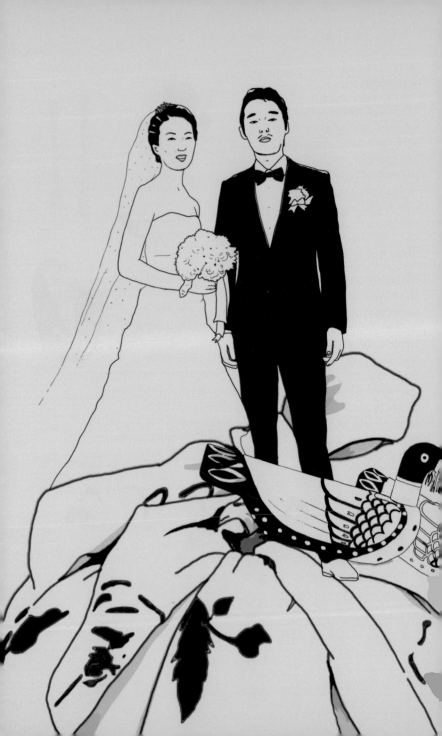

cultural 2

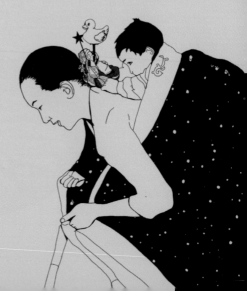

Dishes of Korean Cuisine

A basic Korean meal includes a bowl of rice (or noodles), a soup and simple side dishes (*banchan*): This is the basic structure around which a more complex meal can be constructed, especially by adding more dishes. Some of these dishes are a whole meal by themselves and are served individually (like the *bibimbap*, for example), some are just a kind of appetizer to prepare for the real "meal" (*siksa*: rice and soup with *banchan*) and are generally shared at the center of the table (such as the grilled meat). Here are only few examples of famous Korean dishes.

Bibimbap 비빔밥

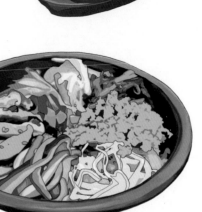

Is it a dish derived from the palace meal (*goldongban*) that included rice with sautéed vegetables and meat, or is it a food tradition drawn from the days when farmers had to eat their whole meal in one bowl on the paddy fields? Whatever the origin, this simple dish became one of the kings of the Korean table: a bowl of rice mixed with sautéed or blanched vegetables, beef, egg, chili pepper paste and sesame oil. There are numerous variants, like the rich Jeonju *bibimbap*, the *dolsot bibimbap* in a sizzling stone-pot and the raw beef variation, *yukhoe bibimbap*.

Naengmyeon 냉면

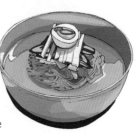

This dish consists of cold buckwheat noodles served with cucumber strips, pear, boiled egg, boiled beef (*suyuk*), mustard and vinegar. They can be served in a beef stock (**mul-naengmyeon**) or without any broth at all, or mixed with a chili pepper paste (**bibim-naengmyeon**). They are best appreciated in summertime when it is especially hot outside, but are also popular as an alternative to rice at the end of a barbecue meal.

Samgyetang 삼계탕

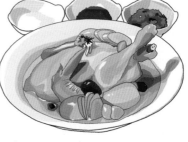

A broth-based chicken soup, *samgyetang* is a favorite among foreigners because it closely resembles the basic chicken stews or soups you'll find in many cultures around the world. The most marked characteristic of the dish is that it features a young chicken, which is cooked slowly in a thick white broth and stuffed with Korean dates, chestnuts, ginseng, garlic and glutinous rice. It is often eaten during the hottest days of July and August or when recovering from sickness because it is said to give lots of energy to those who eat it.

Jeon 전

There are a lot of different kinds of pancakes in Korean food culture. The **bindaetteok** 빈대떡, for example, is a mung bean crepe stuffed with pork, while **gamjajeon** 감자전 is a potato hash brown. The most famous, **pajeon** 파전, is a large crepe made with wheat flour and stuffed with *pa*, or chive, and sometimes seafood as well. *Jeon* are slices of vegetables, tofu or fish that are battered and fried. Each of these dishes are usually associated with alcohol, especially the rice wines (*makgeolli* and *dongdongju*), as well as with rainy days.

Jeongol 전골

Jeongol refers to any type of stew that is cooked in front of you on the table. Its preparation involves a broth that has been prepared in advance, along with sliced vegetables and pieces of meat, fish or tofu, which are then added to be briefly boiled. The texture of these dishes falls between that of a soup and a stew, with noodles being added directly to the broth to make it a complete dish.

Jjigae 찌개/guk 국/tang 탕

As was previously mentioned, soups are an extremely important part of a Korean table and are usually served with rice and other dishes. There are numerous kinds, which are generally named after one of the three following categories: *jjigae*, which are thick soups, similar to stews, the most famous and ubiquitous being the **doenjang-jjigae** 된장찌개, or soybean paste soup; *guk* which are light, sometimes clear soups, like the **kongnamulguk** 콩나물국, or soybean sprouts soup; *tang* which are usually richer soups (traditionally refering to a more "refined" dish), such as beef **seolleongtang** 설렁탕, beef ribs **galbitang** 갈비탕, chicken **samgyetang** 삼계탕, etc. These *tang* can be a meal on their own or the main course amid a larger array of dishes (*jeongsik or baekban*).

Mandu 만두

A great dish from the Manchu and Northern China tradition, *mandu*, or dumplings, can be stuffed with pork, kimchi, tofu and chives, among many other things. They can be boiled in a soup (*mandutguk*), steamed (*jjin-mandu*) or fried (*gun-mandu*).

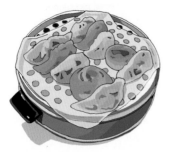

Korean barbecue

One of the most famous items in Korean cuisine, up there with kimchi, is "Korean barbecue," though the most popular incarnation is actually a fairly recent addition to the Korean menu. Regardless of the history, barbecue restaurants have become quite ubiquitous nowadays. Most of the time, meat is cooked directly on the table on portable grills or on built-in charcoal barbecues. Meat can come marinated (*yangnyeom*; used in **bulgogi** 불고기) or plain (*saeng*). **Galbi** 갈비 means ribs. Additional rice and soups are to be ordered as well, because meat is not considered a "meal" (*siksa*) in itself.

Tteok 떡

In a food culture centerd on rice, you can expect cakes and desserts made of rice to be quite cherished. Indeed, Korea has a lot of kinds of *tteok*, or rice cakes, from the very bland *garaetteok* to the very sweet stuffed *chaltteok*. Some are associated with a special festival (**songpyeon** 송편 for Chuseok, as an example), while others are reserved for special ceremonies, such as the opening of a new business or moving (*gosa* ceremonies with *baekseolgi* or *injeolmi*). You can find them not only as a dessert or snack but in dishes like *tteokguk* (rice cake soup) or *tteokbokki* (rice cakes stir-fried in red pepper paste).

Pojangmacha and Street Snacks

Though the street snack vendors that sell goods on the peninsula roadsides are not a uniquely Korean specialty, they have certainly become a part of the charm of the urban landscape—and that's not even mentioning the really Korean-ish delicacies they sell. These portable facilities are movable restaurants and a real heaven for low-budget students, party-goers and soju lovers on the move.

Here are some examples of the most famous daytime *pojangmacha* dishes:

Odeng 오뎅 (or *eomuk*) is a flour-based fish cake that comes in various shapes and forms and is served boiled or deep-fried. It can be prepared as a soup (*odengguk*), but when served on a skewer, it's called "hot bar" because of its shape.

The *odeng* and sausages motorbike stall

Sundae 순대 is a blood sausage very similar to those found in Europe. The country-style *sundae* is stuffed with chopped intestines. The one usually found in city stalls is stuffed with glutinous rice and transparent noodles, arriving steamed and often served with pork liver.

The hotteok pancake seller

Beondegi 번데기 are silkworm larvae braised in their own juices. The dish has a distinctive smell and is strange in appearance, but is a delicacy for children.

Tuigim 튀김 is the Korean version of Japanese tempura: chili peppers, shrimp, sweet potatoes, perilla leaves, eggs . . . They are all delicious when battered, fried and eaten with *tteokbokki*!

Tteokbokki 떡볶이 are rice cakes cooked in a sweet chili pepper sauce with *odeng* and boiled eggs.

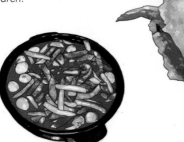

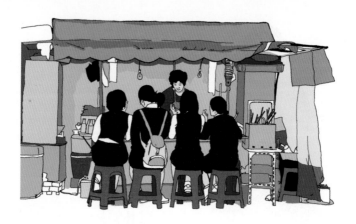

Pojangmacha 포장마차 is a general term for the tented food stalls set up on the pavement at the side of a street. The daytime versions serve simple snacks to eat on the spot or take away, targeting the school pupils and busy passers-by. The stalls themselves can be a converted truck or a tent, usually identifiable because of their recognizable orange color. The nighttime *pojangmacha* serve alcohol until dawn, acting as street bars where people socialize while eating snacks, or *anju*. They are simple but comforting, and people still like to meet at these places as a way to get rid of stress and have sincere talks, facilitated by the vapors of alcohol—or sometimes even go by themselves. There are around 3,000 of such stalls in Seoul alone. New kinds of concrete-built *pojangmacha* (or *pocha*) have become popular, but they are closer to bars and, except from the *anju* culture, they don't have much to share with the distinct atmosphere of their tented ancestors.

Gimbap

Here is a non-exhaustive list of **anju** 안주 served in *pojangmacha* and bars:
Dubu kimchi is panfried kimchi served with steamed tofu, a wonderful match of spicy and mild.

Golbaengi and *somyeon* are another classic snack pairing: a spicy salad with freshwater snails served alongside thin white cold noodles. These spicy snacks are excellent with strong liquors like *soju*.

Ojingeo, dried squid served with chili pepper paste, and *ttangkong, or* peanuts, are the snacks par excellence for beer-drinking in Korea although in recent years they tend to have been replaced by fried chicken, the famous *chimaek* (a combination of the English word "chicken" and the Korean word for beer, "*maekju*")

Jokbal is pork trotter glazed and served cold in slices with a shrimp sauce—readily available in most convenience stores to complement *soju* parties.

Gopchang is a traditional *pojangmacha* snack that is becoming more common as a meal. The dish is pork intestine sautéed with or without chili paste, and can also be grilled.

Buchimgae refer to all kinds of pancakes, crepes and pan-fried foods such as *jeon*, and are perfect with *makgeolli* on a rainy day.

All manner of dried fish are often served with alcohol, from small anchovies (**myeolchi**) to flat **jwipo**.

In many bars and clubs, fruit plates are still served as expensive *anju*, but cheese plates are gaining popularity as a chic form of side dish for wine and liquor.

The famous *pojangmacha* orange tent

Kimchi

Kimchi 김치 is the king of the *banchan*, or side dishes, and is one of the three essential elements of the basic Korean meal along with rice and soup. It is the most common side dish, and in very simple meals, it may even be the only one. In terms of image, kimchi is the equivalent of the baguette in France or pasta in Italy, although, functionally, it is closer to pickles. Unlike rice, which is a staple in a multitude of cultures around the world, kimchi is a true emblem of Korean national heritage, with an entire museum devoted to it in Seoul. It's a cold, and fermented dish that is typically vegetable-based. Different kinds of ingredients can enter the mix depending on where it's made, but a crucial aspect of its creation is that it is usually preserved for a long time. Kimchi is traditionally fermented and stored in *dok* 독, the beautiful earthen jars made especially for this purpose, and kept on a backyard platform called *jangdokdae*.

The history of kimchi

Although historians have not yet established an exact date for the invention of kimchi, there is reason to believe that its origins are tied to the development of agriculture during the Neolithic era. It was certainly prepared at the time of the Three Kingdoms, since Koreans at that time prepared dishes fermented and soaked in salted water, like soy sauce and pickled seafood.

Originally, the dish simply consisted of fresh vegetables plunged in brine. Toward the end of the Three Kingdoms, however, condiments such as spring onion, garlic and ginger were added to the recipe, which eventually became more commonplace during the Goryeo era. After being mixed with the condiments, the vegetables were then salted and put to ferment, making it possible to

preserve them for longer periods of time. It was around this time that Napa cabbage (**baechu** 배추) may have been introduced to Korea. The greatest advances in kimchi preparation took place during the Joseon era, between 1392 and 1910. In addition to several ingredients being introduced from China, the chili pepper arrived after the Japanese invasion of 1592; the red, spicy vegetable soon found itself integrated into the preparation of kimchi and the Korean palate in general, to the point that chili peppers can now be found in a lot of Korean dishes. The use of fish brines, an ingredient with a long history on the Korean Peninsula, also became common for fermentation around this time.

Another significant leap occurred at the beginning of the 19th century when the method of the double salting was widely adopted. For this process, the main vegetable is salted and left a few hours to discharge its water before being rinsed. After this point, the various condiments and spices are added (ginger, garlic, spring onion, radish, chili pepper, mustard seeds, chestnuts, meat, fish and oysters, among other things), and then it is seasoned with salt, soy sauce or salted fish or shrimp. In addition to adding animal protein to the final product, this seafood brine also encourages both fermentation and conservation—a method that is still used today.

Kinds of Kimchi

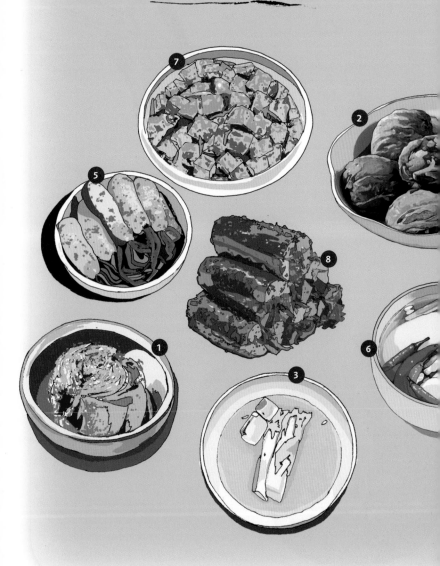

1. Baechu kimchi (whole cabbage)

The most popular kimchi in Korea is certainly the one made with Chinese cabbage.

When no precision is given, kimchi usually designates the cabbage kimchi.

2. Bossam kimchi

Wrapped and stuffed with many ingredients such as oysters, gingko seeds, chestnuts and pine nuts, *bossam* kimchi is delicious with *suyuk*, or boiled pork slices, a traditional dish/snack.

3. Baek kimchi (white cabbage kimchi)

This is the original form of kimchi, which is quite watery and prepared without chili peppers.

4. Nabak kimchi (radish in brine)

Nabak kimchi is another kind of *mul* kimchi or watery kimchi, made with *mu*, or white radish slices, cucumber, pear and pine nut—an aristocratic kimchi!

5. Chonggak kimchi

This kimchi is made with young white radish, also called oriental turnip, or *chonggakmu*. Its shape evokes the top-knot hairdo worn by bachelors (*chonggak*) in ancient times.

6. Dongchimi (whole radish in sweet brine)

Dongchimi is served in wintertime as a cold soup whose sweetish broth is enjoyed as much as the radish itself, for example in *naengmyeon*.

7. Kkakdugi (radish cut in cubes and spiced)

Kkakdugi is delicious and crispy, often served with chicken, *samgyetang* and a variety of other dishes.

8. Oi-sobagi

There are also many variations using virtually any kind of vegetables, like the delicious *oi-sobagi*, or stuffed cucumber kimch.

Kimchi: food or medicine?

 Whatever the form, kimchi is a part of all Korean meals. Its flavor can be a bit of a shock at first because of its combination of salt, acidity and spiciness, not to mention the fact that fermentation can produce a rather strong smell. But it is also said to be a true panacea: Fermentation provides the lactic acid that is otherwise absent from Korean cuisine, which does not traditionally include dairy products; the chili pepper, delivering 10 times more vitamin C than an orange, offers energy and intestinal antisepsis; the fiber promotes regularity; and the spices stimulate one's metabolism. Combined, the various ingredients are believed to protect from certain cancers and drain the arteries, as well as helping to manage hypertension and diabetes. In short, there are as many virtues, proven or suspected, as there are types of kimchi.

Caution: Like any fermented food that's usually salty, sometimes spicy and always rich in fiber, kimchi should not be eaten in excess. Instead, it should be incorporated into a balanced meal that also includes other types of nutrients—otherwise, the effect could be the opposite of its supposed virtues.

Nowadays, the kimchi commonly eaten by busy urbanites is made in factories (and may not be as much of a miracle food as publicized). But between November and December, however, family members and neighbors still gather to make the ***gimjang*** 김장, or winter kimchi, which will be kept in an earthen pot buried in the ground to provide a daily ration of vegetables during the colder months.

Jangdokdae

Korean cuisine identity largely revolves around fermented products, especially the *jang* 장, or basic ingredients coming from the processing and fermentation of the soybean: *ganjang*, or soy sauce; *doenjang*, or fermented soy bean paste; *gochujang*, or red pepper paste; and in part, the *jangajji*, or fermented pickles. These ubiquitous condiments have a special place for them in the traditional house: the *jangdokdae* 장독대.

In a traditional home, the place for kimchi, *ganjang*, *doenjang* and *gochujang* jars was a low platform in the back of the house called *jangdokdae*. Since these delicacies are the basis of Korean cuisine, the *jangdokdae* was an essential part of the household. It was built on a small stone foundation to keep it away from excessive moisture, and situated in a cool place at the back of the house to be protected against the cold winds of winter.

Soybeans (*kong*) are a versatile ingredient in Korean cuisine from which many basic condiments of everyday meals are derived. Everything starts with the fabrication of one of the standards: soy sauce (**ganjang** 간장). Soy beans are soaked in water, boiled and then mashed and pressed before being left to ferment and dry in the form of a square or circular block.

Once dried, this brick, or **meju** 메주, is put into a huge earthen pot along with brine, charcoal and dried chilli pepper. After few months, the mixture is filtered and the dark, salty and fragranced sauce, *ganjang*, is used to season a multitude of dishes.

Oak wood charcoal

Meju

Red chili pepper

Meju

Soybeans are soaked in water for 12 hours before being boiled. The beans are pounded to a paste. The paste is shaped in circular or square bricks, which are then dried for around two weeks. The bricks are tied with a rice straw rope and left to ferment for about a month. Finally, the bricks are hung outside in sunlight to dry until use.

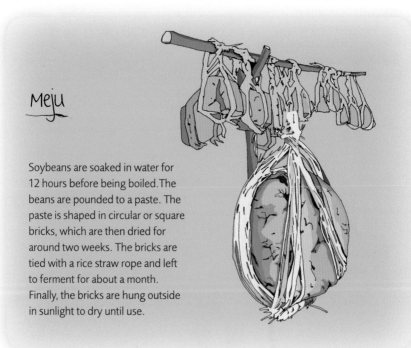

The other basic Korean sauce is **gochujang** ^{고추장}, or red chili pepper paste: it is a blend of red chilli powder, malt and sticky rice flour, and may also include sesame oil, sugar or even a little bit of *meju* or *cheonggukjang* powder. Spicy and deep red, it gives a sharp flavor and a touch of color to stews, meats, fish and vegetable dishes. As is the case with other sauces and pastes, it is traditionally stored in earthenware.

The remaining *meju* is not thrown away: It is mixed with different ingredients to make **doenjang** ^{된장}, or soybean fermented paste, used mainly in soups and stews (*jjigae*), but also as a dipping sauce. It is the Korean equivalent to Japanese miso, but strong in taste and rougher in appearance. Soaked and crushed soy beans are also used to make tofu, called *dubu* ^{두부} in Korean. Contrary to popular belief, bean sprouts are not always soybeans, but the smaller version comes from the sprouted mung beans. **Cheonggukjang** ^{청국장} is another form of fermented soybean paste. Soybeans are soaked and boiled, similar to the process for *meju*, but they are neither crushed nor put out to dry: Instead, they are left to ferment in a warm room. It becomes in few days a pungent paste which is used fresh for soups and stews.

The name kimchi is said to come from the ancient word *dimchae*, used to describe salted and marinated vegetables. This name has now been taken on by a refrigerator brand used especially for kimchi. Traditionally, however, kimchi was fermented and stored in the beautiful earthenware (**dok**, *or* **onggi**) that could once be seen Korean backyards, but is still seen on many patios and rooftops.

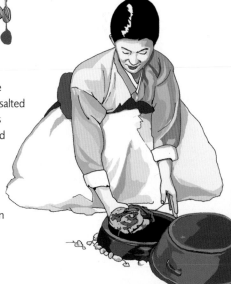

Drinking Culture

Alcohol in Korea is not only a drink; it is part of a "culture" (*sul-munhwa*) that has its own rules and habits. Like all countries, Korea has its own traditional alcoholic beverages, but this is not the tradition to which the aforementioned "culture" is referring. Rather, Korean drinking culture is directly linked to the hardships of recent years when, in light of a very repressive society (a neo-Confucian background combined with a military dictatorship), alcohol became one of the rare ways to cope with stress. It is a specifically male-oriented culture, which is why we present the drinking customs alongside a description of the typical "salary man evening."

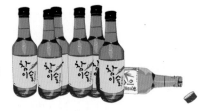

Traditionally, most Korean alcohols were derived from either fermented or distilled rice. In addition to these offerings, some liquors were also made from fruits and berries. Here are a few of the options available:

Soju 소주: The most famous on this list, millions of bottles of *soju* are sold every year because it is both strong and cheap! Traditional *soju*, like the one still brewed in Andong, is a very clear, distilled rice liquor that is also quite strong (45 percent alcohol by volume). Nowadays, however, *soju* includes a blend of ethanol (made with cereals or sweet potatoes), water and flavouring agents, and is generally 20 percent ABV. The latter was promoted during President Park Chung-hee's era as a way to limit the consumption of rice and cheer up the spirits during times of economic reconstruction. Since then it has become a national drink, consumed to celebrate success, enhance joy and alleviate pain.

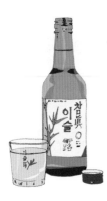

In 2011, *soju* brand Jinro was the world's most-consumed liquor, with 61.4 million 10-litre boxes sold. The world's third most sold alcohol was another *soju*—this time a brand from Lotte Liquor. Bearing in mind that *soju* consumption is mostly a domestic pastime, it tells you a lot about the amount of love Koreans have for the little green bottle!

Makgeolli 막걸리, **dongdongju** 동동주 and **cheongju** 청주 are fermented rice alcohols, thick and soft (6–7 ABV for *makgeolli* and *dongdongju*, 13 and higher for *cheongju*). They can be made at home (thus the past title of "farmers' beer") and also mixed with plants like kudzu vine (*chik*), flower petals and other cereal. *Makgeolli* is the first product of fermentation, thick and whitish, usully softened with syrup or sugar and water and slightly fizzy. *Dongdongju* is the next step—a little clearer. *Makgeolli* and *dongdongju* are also designated as *takju*, or turbid rice-fermented alcohols.

Cheongju is the filtered alcohol when the first fermentation has stopped and can be kept for longer periods of time. It is used as an offering at memorial ceremonies for ancestors. *Makgeolli* has experienced a bit of a comeback in recent years thanks to a sudden surge of interest in Japan. Trendy *makgeolli* bars have begun to open up all around Korea as well, although it is not clear if this trend will last.

Baekseju 백세주 is a modern alcohol, a rather sweet blend of different medical plants supposed to make you live a hundred years (hence the name: *baek*, meaning one hundred, *se*, meaning year and *ju*, meaning alcoholic beverage). Its closest competitors are the "reinvented" traditional liquors made from different local plants and berries: *gasiogalpi* (Siberian ginseng), *bokbunja* (black raspberry), *sansuyu* (dogwood), etc. Another sweet favorite is *maesilju*, or green plum liquor.

And, of course, there are beers (quite light): Cass, Hite and Max are mainstays, and local whiskies are also popular. In recent years, microbreweries have been flourishing.

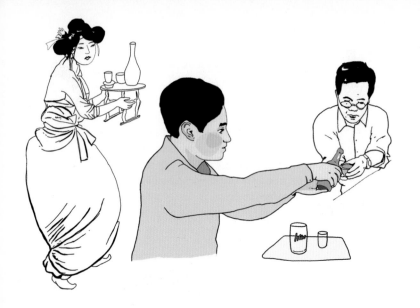

Welcome to the binge drinking paradise!

When drinking alcohol in Korean companies and organizations that are very hierarchal, you could be required to follow very strict rules or customs. Even if drinking is a way to get rid of stress and to find ways to solve problems and issues not addressable when sober, the neo-Confucian hierarchy remains present at all times. One of the most important thing to remember is that you never drink alone; always wait for the older person to initiate the drinking by making a toast. You will serve that person and wait to be served by someone else, often the person you have just served, but never pour alcohol to yourself! It is also customary to exchange glasses; if someone who wants to honor you offers his full glass, you take it and drink it at once—one shot! You can say *geonbae* 건배 (cheers)

loudly, since it is customary to drink after a toast, not to individually sip your drink (*soju* glasses are small, thankfully).

After you've finished, give the glass back and pour alcohol to the other person in return. Always serve and receive alcohol with two hands, and if possible, try not to sip or drink in front of elders: Turn yourself slightly away. ***Anju*** 안주, or finger food, is always ordered with drinks because, since they drink quickly and heavily, Koreans like to eat as a way to counterbalance the effects of alcohol. Because of the complicated nature of these overly strict customs, they are starting to disappear among younger generations. You'll see a lot of fighting when paying the bill, as everyone wants to pay for the group. "Dutch pay" (separate bills) is not a habit.

Each stage of an evening of drinking is its own stage. After a quick dinner where different liquors are taken (*il-cha*, or first stage), a group of colleagues or friends often go to the second stage, or *i-cha*. At this second location they will typically drink more, often stronger liquors like *soju* or *poktanju*, consumed alongside more *anju*. Once everyone is drunk, it is then time for a karaoke (*noraebang*) where there is no alcohol served . . . in theory (**sam-cha**, or third stage).

Those who want more alcohol and would like to enjoy the company of hostesses can go to one of the many "room salons." If the person is still alive after all these steps (or *cha: sam-cha, sa-cha*), he can go back home, sleep in a sauna or, in some cases, pass out in the street. Fortunately, there is the **daeri unjeon** service where, for a reasonnable price, a driver will come and drive the drunken person home safely in his own car. He will be tired in the morning, but he has gotten rid of his stress, expressed his anger and improved team spirit, making him socially ready for a new day of work! And let's not forget that in Korea we have a lot of morning-after dishes, such as the famous **haejangguk** , or hangover soup.

HOW to make poktanju

Poktanju 폭탄주, or bomb-drink, is a cocktail made with a shot of liquor, in the past usually whisky, poured in a glass of beer, struck on the table and drunk in one go. The most popular *poktanju* these days, called **somaek** 소맥, is made of *soju* and beer.

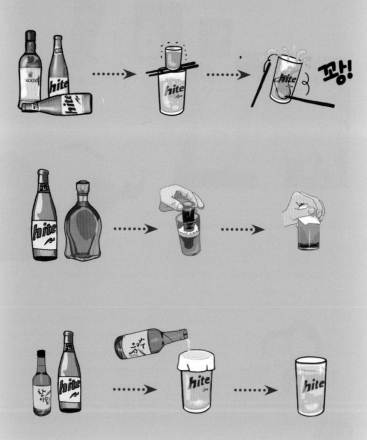

Festivals and Holidays

Korea uses the Western solar calendar, but its traditional holydays and festivals are set according to the lunar calendar. Most of Korean calendars show both dates. The lunar calendar corresponds to different solar days every year.

1 January (solar)*: New Year
1 January (lunar)*: Seollal or Lunar New Year
1 March (solar)*: Independence Movement Day, celebrating the uprising for independence of 1 March 1919
5 April (solar): Tree Planting Day, dedicated to the reforestation of the country

5 April (lunar): Hansik, a day to celebrate the beginning of the warm season and of the sowing with a cold meal and offerings on the tombs of ancestors (the 105th day after the winter solstice, approx. April 5 by the Gregorian calendar)
8 April (lunar)*: Buddha's Birthday, a big festival celebrated in every temple and in the main avenues of cities, with lantern

parades and Buddhist ceremonies

1 May (solar): Labor Day, which is not a public holiday in Korea!

5 May (solar)*: Children's Day

5 May (lunar): Dano ,a planting season celebration

8 May (solar): Parents' Day

15 May (solar): Teachers' Day, important celebration in a Confucian country

6 June (solar)*: Commemoration Day, in the memory of the patriots dead for the nation.

17 July (solar)*: Constitution Day, celebrating the promulgation of the first republican constitution in Korea in 1948

15 August (solar)*: Liberation Day, celebrating the end of the Japanese colonial occupation in 1945

15 August (lunar)*: Chuseok

3 October (solar)*: National Foundation Day, celebrating the mythical founding of the Korean nation by Dangun in 2333 B.C.; there is a ceremony on the Mani Mountain on Ganghwa-do Island.

9 October (solar)*: Hangeul Day, commemorating the invention of the Korean alphabet in the 15th century by the King Sejong the Great

25 December (solar)*: Christmas, an imported holiday celebrated by the numerous Christians of the country

* Public holiday

The four traditional holidays in Korea are Seollal, Hansik, Dano and Chuseok. Only the first and last ones are public holidays. **Seollal** 설날 is the Lunar New Year festival when people go back to their hometowns (*gohyang*) to visit their family, offer formal salutations to elders (*sebae* 세배, New Year's deep bow), wish them a Happy New Year and receive money from them as a gift. Early in the morning there is a ritual to the ancestors in front of an altar full of food (*charye*). After lunch, people go to visit relatives and perform a ceremony at the family tombs (*seongmyo*). In the past, there were dances and folkloric games in the countryside. People usually take few days of vacation at this time, and many shops are closed around town.

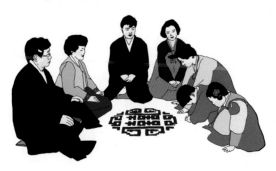

The 15th day of the 8th lunar month (falling sometime in September or October) is the day of **Chuseok** 추석, the most important Korean holiday. It is the harvest festival, when people get ready to enter wintertime and pay homage to their ancestors. It resembles Seollal in many ways, and could be compared to the Western Christmas for its importance and All Saint's Day for its function.

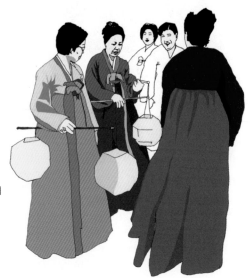

National Symbols

Every country has a selection of icons around which it can confirm its own national identity. These symbols are typically chosen because they express the way the people would like to see themselves, as well as the values they cherish. After the Korean War (1950–1953), Korea developed its own collection of such national images, most of them rooted in traditional culture. A bit more modern in nature, these official symbols are slightly different from the traditional ones that we'll see later.

The national flag, or Taegeukgi 태극기

The Korean national flag embodies the deep ideals of Korean people. The central *taegeuk* circle symbolizes the balance of the universe that is driven by the rotation of the *yin* (*eum* 음 in Korean, blue, earth, female force) and *yang* 양 (red, heaven, male forces). If the circulation of one force in the other is even, like in the design, it will generate the basic virtues necessary for human happiness. These virtues are symbolized in the flag by four of the eight trigrams, or *gwae*.

Clock-wise from upper left: *geon*, or justice in heaven; *gam*, or wisdom; *gon*, or abundance; *ri*, or light. The harmony thus realizes a state of universal peace and purity symbolized in the white background. The *taegeuk* sign, linked with the Taoist philosophy, has been used in Korea since as far back as the 7th century. The flag was officially declared the national flag in 1883, and then again in 1949 after Korea's formal liberation from Japanese occupation in 1945.

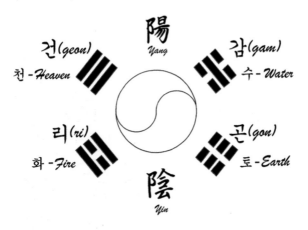

The Rose of Sharon, or mugunghwa 무궁화

This flowering tree native to East Asia has been mentioned since old times in Chinese books about the Peninsula. Its flowers blossom in the morning and fall off in the evening, producing new blooms for up to 100 days—perhaps the reason why the tree's Korean name means eternity. It was mentioned in 1907 in the national anthem, and because of its symbolic qualities, this flower is considered as one of the national emblems of Korea.

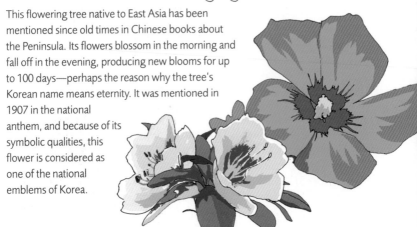

The magpie, or kkachi 까치

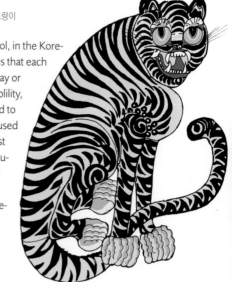

The magpie has been the official bird of Korea since 1964. Unlike much of the wildlife in Korea, it can be found everywhere, even in cities. The bird represents the countryside spirit—the presence of every Korean's hometown in the back of their mind—and is said to bring both good news and general good luck. Present in many legends, a pair of magpies also symbolizes the Chinese character 囍 (*hi*), meaning happiness.

The tiger, or horangi 호랑이

Although not an official national symbol, in the Korean psyche, the tiger embodies qualities that each person would like to possess in one way or another—courage, ferociousness, noblility, strength—which are all virtues needed to succeed in our modern world. Korea used to be called a roaring tiger for its robust economic growth in the late 20th century. In traditional imagery, the tiger acts as a symbol of the *yangban*, or noble class, and the magpie is sometimes presented as the common people, who mock the nobility.

Chiu Cheonhwang 치우천황

The Chiu Cheonhwang is the Korean version of the Chinese mythical being Chiu. Chiu was a fierce tribal leader with the head of a bull and the body of a human who fought against the future Yellow Emperor. He has been worshipped by some as a god of war of sorts, and his stylized face became the mascot of the Red Devils, the supporters group of Korean national soccer team.

The mythical creatures

The pheonix, or **bonghwang** 봉황, is a mythical bird said to be reborn from its ashes. It has become a symbol for Korea, and is especially associated with the president.

Haechi 해치 is a mythical animal that, according to legend, is supposed to protect places from fire and disaster. It has the appearance of a lion with its huge teeth, nose and eyes. *Haechi* is sometimes represented in the form of a stone statue, the most famous of which being those placed outside the gates of Gyeongbokgung Palace (Gwanghwamun) to ward off the devil spirits. The animal became the mascot of the city of Seoul in 2008.

Admiral Yi Sun-sin 이순신

Yi Sun-sin (1545-1598) is known to many as the most venerated soldier in Korean history, an emblem of Korean persistance. In 1591, sent as a navy commander in the Jeolla region, he designed the famous turtle ship, or **geobukseon**, a metal-armored boat. Equipped with these vessels and a good knowledge of the waters around the southern coast, he faced the Japanese invasion of 1592 and, over the course of five years, led the armies that destroyed a large part of the Japanese fleet. He died during battle in December 1598. Also known under his honorific name, Chungmu, he symbolizes courage, loyalty and the patriotic spirit. His statue in Seoul is hard to miss on Sejong Avenue, and he also has an avenue of his own—Chungmuro.

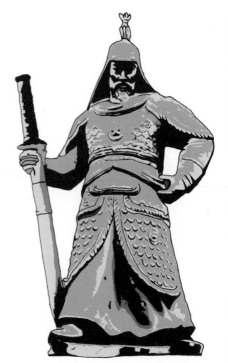

Money Figures

1,000	Yi Hwang is one of the most prominent Korean Confucian scholars of the Joseon Dynasty. A key figure of the Neo-Confucian literati, he established the Yeongnam School and set up the Dosan Seowon, a private Confucian academy close to Andong. Yi Hwang is also known by his pen name Toegye ("Retreating Creek"). An avenue in Seoul bears his name (Toegye-ro).
5,000	Yi I was the other great Korean Confucian scholar of the Joseon Dynasty. Yi I is often referred to by his pen name Yulgok ("Chestnut Valley"). He is not only known as a scholar but also as an integer politician and a reformer.
10,000	The fourth king of Joseon, who began his rule in 1418, Sejong is the most famous and beloved of the Korean kings. He was integral to the development of the nation's arts and music culture, and ordered that books be published in many fields that would be useful to his people. He created the Hall of Worthies (Jiphyeonjeon), an academic institute where around 20 scholars devoted all of their time to research. He played a pivotal role in the creation of the Korean alphabet, Hangeul, intended to make knowledge available to everyone, not just the educated elite. He is celebrated on Hangeul Day (9 October) and King Sejong's Day (15 May). The main avenue in downtown Seoul bears his name (Sejong-ro).
50,000	Mother of Yi I, Sin Saimdang was a talented artist and a cultured woman who also embodied the moral virtues of the Confucian wife and mother.

Games

Yeon 연

Spanning cultures the world over, kites enjoy a near-universal status as a form of entertainment for children and adults alike. They are called *yeon* in Korea and can be true works of art, made of sturdy Korean paper and either painted or otherwise decorated. Kite flying is especially popular at the Lunar New Year, Seollal.

Yut 윷

Yut is a game made of two pieces of wood cut in half. They are thrown on the floor and the way they fall makes a value worth points: *do*, *gae*, *geol*, *yut* and *mo*. According to the points earned, the player can make his or her pawn move ahead on the playing board (*yutpan*). This game is traditionally played at Seollal, or for the first full moon of the year.

Gawi, bawi, bo 가위바위보

The name of this game literally translates as "scissors, stone and cloth", and is very similar to the Western game "rock, paper, scissors." To play, people hide their hand behind their back,

가위 바위 보

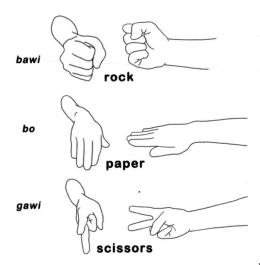

bawi

rock

bo

paper

gawi

scissors

chant the name of the game as a song and, when finished, reveal their hand in the shape of one of the objects: two fingers for the scissors, fist for the stone and flat palm for cloth. Scissors beat cloth; cloth beats stone (it can wrap it); stone beats scissors. Despite being a simple children's game played for fun, it is used a lot in different situations to make minor decisions very quickly.

Baduk 바둑

This game originated in China, and is better known in the West under its Japanese name, *go*. This strategic game is played by two people on a grid with black and white pieces. One has to surround the opponent's pieces in order to win the territory they occupy. It is very popular in Korea, and there is a cable channel dedicated to *baduk* as well as many online game sites.

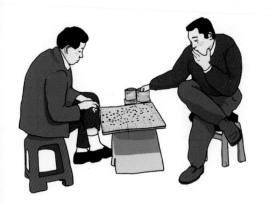

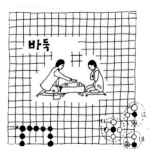

Neolttwigi 널뛰기

Neolttwigi is a game that was tradi-
tionally played by women on
such holidays as Lunar New
Year, Dano (the 5th Day of
the 5th Lunar month) and
Chuseok. The premise
is simple: Two players
stand on opposing sides
of a see-saw, and the goal is
to make the opponent fall from the
board. In the old Joseon society where women of the
upper class couldn't go out of their houses easily, it is
said that this game provided an occasion to jump high
enough to spot young men passing by the wall.

Hwatu 화투

Like a Western card deck, this
"game" is made of 48 cards and,
just as is the case with Western
decks, it can be used for
divination or a multitude of games
meant purely for entertainment.
The name *hwatu* means "flower's
battle," and despite coming from
Japan originally, it has become
very popular in Korea. One of the
games played with *hwatu* cards is
called go-stop, and is even
practiced online.

Jegichagi 제기차기

Jegi is a shuttlecock made of either a coin or stone wrapped in cloth or paper. A popular game among children is to make the *jegi* bounce on one's foot as long as possible without letting it fall on the floor.

How to make a jegi

①

②

③

④

⑤

⑥

Tuho-nori 투호놀이

The player of this game has to throw thin arrows into the neck of a jar. It was played during Joseon times by aristocrats who were on holiday. Nowadays, it has become a common game played on special occasions.

The Korean Alphabet, Hangeul

The Korean language has been linked to the Altaic linguistic family (Mongolian, Turkic, Manchu-Tungus, etc.). And although around 70 percent of its present vocabulary has Chinese origins for cultural and historical reasons, it is still very different from the Chinese language linguistically. As a result, Chinese characters, which were originally used to represent the language, were never able to properly render Korean-specific sounds and grammar. Moreover, Chinese characters are known to be very difficult to learn. For this reason, under the impulsion of 15th-century leader King Sejong, a unique Korean alphabet has been invented to write Korean: the famous and much-admired Hangeul.

symbol of heaven *symbol of earth* *symbol of man*

A script that is riddled with spiritual conceptions, Hangeul 한글 is often described by experts as the first "scientific" alphabet, showing a deep understanding of linguistics and of the Korean phonology. It is rooted in five basic consonants (ㄱ, ㄴ, ㅁ, ㅅ, ㅇ) whose shape was designed after the actual positions of speech organs while speaking, as shown below.

velar *alveolar* *bilabial* *dental* *glottal*

ㄱ ㄴ ㅁ ㅅ ㅇ

To this scientific approach, spiritual conceptions were added for the creation of the vowels. The three basic forms were ㅣ (the long "e" sound), which symbolizes humanity, making the link between ㆍ (the short "a" sound, in the past writing), which symbolizes the heaven, and ㅡ ("eu"), which symbolizes Earth. When combined in different ways, these three elements are used to construct all of the Korean vowel sounds. They represent the harmony of humanity, heaven and Earth as leading principles of the universe (cheonjiin), reflected in language.

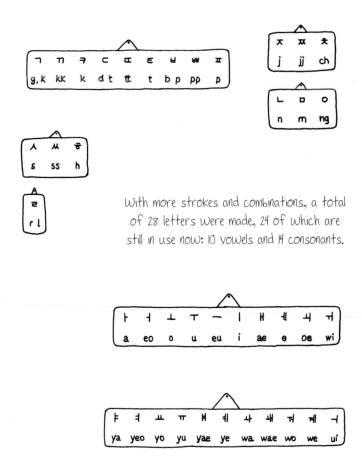

With more strokes and combinations, a total of 28 letters were made, 24 of which are still in use now: 10 vowels and 14 consonants.

A syllabic alphabet

Whereas Chinese script is a system of ideograms (one sign represents a meaning, usually not a sound), Hangeul is an alphabet: It is a set of signs that can be combined, each one representing a sound or phoneme. But the system is based on syllables, and a sign can't appear alone, which is different from the Roman alphabet.

Letters have to be combined in syllables (2, 3, 4 or 5 phonemes), ideally written in imaginary squares. This allows Hangeul to be written in vertical or horizontal order.

한 글 = HANGEUL

ㅎ + ㅏ + ㄴ = 한
H + A + N = HAN

ㄱ + ㅡ + ㄹ = 글
G + EU + L = GEUL

From King Sejong's "invention" to the alphabet of the Korean people

Hangeul originates from King Sejong's very democratically minded desire to enable all of his people to write their thoughts and feelings in their own language. This idea was especially revolutionary in 15th-century Korea, a time when classical Chinese was not only the official and sole script but also a symbol of power among the literati class. Responsibility for the invention was put in the hands of Jiphyeonjeon, the Sejong-established academic research institute, and in 1446 the Hunmin Jeong-eum (or Correct Sounds for the Instruction of the People, Hangeul's original title) was officially approved for public distribution. It was initially intended to be taught to the more underprivileged classes in society—uneducated people, women and children—but was scorned at and even criticized by scholars, apprehensive about the privilege it would bestow upon these groups.

As a result, some books were written in Hangeul, but the elite literature was still in classical Chinese until the end of

the 19th century. It was only under pressure from foreign acculturation and 19th-century invasions (Westerners, Japanese), and also a slow democratization that Hangeul became widely used. As a result, it became the "script of the Han people" (Hangeul) or the official alphabet, so simple and practical that it helped reduce the illiteracy rate of post-war Korea to almost zero. It is now celebrated on October 9 every year, a national holiday.

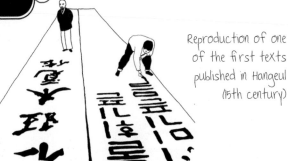

Perfect to transcribe Korean phonology and even relatively good for other languages, such as Chinese, Hangeul can be mixed with Chinese characters in a single text to express their meaning and pronunciation.

Reproduction of one of the first texts published in Hangeul (15th century)

Royal Shrine Ancestral Ritual

Every year since 1971, the Jeonju Yi Royal Clan Association has been performing the 500-year-old royal shrine ancestral ritual, Jongmyo Jerye 종묘제례, on the first Sunday of May. Incorporating stately costumes, court music and dances, the Confucian celebration is a fascinating spectacle to behold.

The **Jongmyo Shrine** 종묘, located in Jongno, downtown Seoul, is a large compound that houses the primary worship site for the Joseon Dynasty (1392–1910) royal family. It was one of the first structures to be built when Seoul was officially named as the nation's capital in 1394. After its completion in 1395, the first king of the dynasty, Taejo, moved his ancestors' tablets to the new shrine. The shrine needed to be rebuilt in 1608 after the Japanese invasion, with this 17th- century structure being the one that still stands today, albeit renovated and enlarged many times until the end of the 19th century. Not only the Jongmyo Shrine has been designated a World Heritage by UNESCO, its specific rituals (Jongmyo Jerye) and music (Jongmyo Jeryeak) have also been

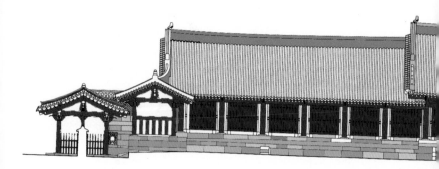

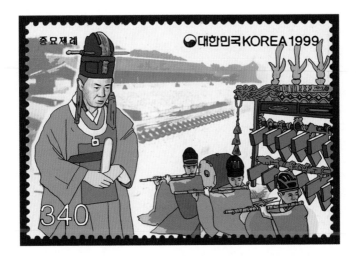

recognized by the organization.

The Jongmyo grounds are the site of a number of different buildings dedicated to the tablets and rituals of royal ancestors. There are two shrines that also sit in this area: Jeongjeon (Main Hall) and Yeongnyeongjeon (Hall of Eternal Peace). The former hosts the tablets of 19 great kings and their 30 queens, while the latter is an auxiliary shrine built by King Sejong for less honorable kings, posthumous kings and crown princes. Smaller in size, it is also the repository of the tablets of four generations of the clan (prior to 1392).

To the right of the entrance is a hall hosting 83 tablets of Joseon citizens of great merit (Gongsindang). On the left is an altar to the seven deities protecting the compound (Chilsadang). Outside of

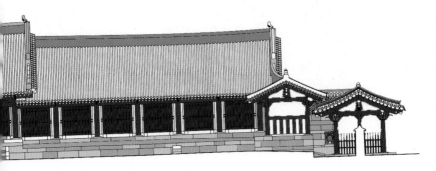

Jeongjeon is a building (Eosuksil) where the king used to bathe and rest before partaking in palace rituals. In the back is the kitchen (Jeonsacheong), used to both prepare ritual food and store bronze utensils, which had special significance in the Joseon era.

The Jongmyo Jerye rites involve some 300 participants, most of them being members of the Jeonju Yi Royal Clan. It is a long and slow ritual inspired by the original Chinese tradition, with the music dating back to the Zhou Dynasty. First, the master of ceremonies welcomes the royal ancestral spirits, and then there is a presenting of white ramie as a tribute to the spirits. Next is the offering of food and three offerings of wine, each accompanied by invocations and prayers. Finally, the offerings

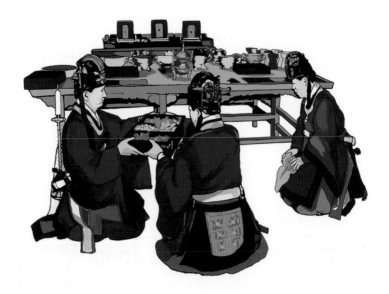

are removed and the spirits are believed to be sent off. The ritual ends after few hours with the burning of the invocation sheets and ramie cloth.

In the past, the ritual started at midnight and was held until the morning, including 700 participants in total. It was held in its complete form (*daeje*) five times a year—once at the beginning of each season and once more at the end of the year—but also for special royal occasions like weddings or coronations. After being stopped for 60 years due to Japanese occupation, it is now held once annually and under the patronage of the Yi Clan Association.

Artistic

3

Calligraphy

The practice of calligraphy, or *seoye* 서예, first came to Korea from China, but has remained largely popular throughout the Peninsula since it arrived. It is not only the original way to write Chinese characters, it is also an art in its own right. Alongside literati painting, calligraphy once occupied a significant portion of scholars' education and free time, with considerable overlap between the techniques and materials of these two arts. The purpose of practicing calligraphy was to express one's personality and virtue.

Mastering proper calligraphic technique is a skill that demands long and consistent training. There are specific ways to hold the brush (①) and ②), for example: It must always be held in such a way that keeps it perpendicular to the paper and without the wrist rotating, allowing the arm and shoulder to do all the movements (③).

When writing letters or documents on a scroll, people used a *seoan*, or low table. The traditional materials needed to do calligraphy were called *munbanggu* 문방구 and consisted of brushes (*but*) made of bamboo and either racoon, dog, rabbit or weasel hair; mulberry paper (called *hanji* if made in Korea) held in a paper holder (*jitong*); an ink stick (*meok*) that was slowly rubbed on an ink stone (*byeoru*) with drops of water poured from a ceramic water container (*yeonjeok*) to produce dark and thick ink; a *piltong*, or brush holder; and *seojin*, or paper weights to hold the paper on the floor or writing surface. These materials were a regular sight in the *sarangbang* 사랑방 (men's quarters and leisure room), and the paper, brush, ink and ink stone were called *munbangsau* 문방사우, or four friends of writing.

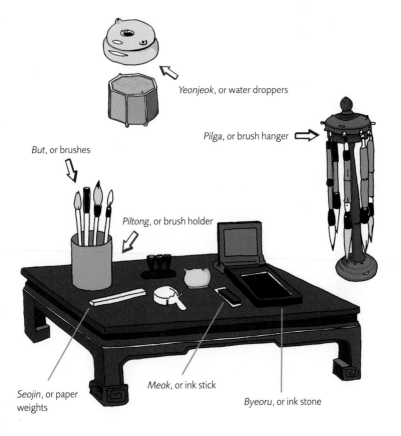

Yeonjeok, or water droppers

Pilga, or brush hanger

But, or brushes

Piltong, or brush holder

Seojin, or paper weights

Meok, or ink stick

Byeoru, or ink stone

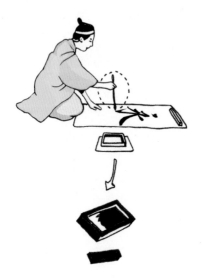

The *yeong* character (永), which means "eternity" in classical Chinese, is said to contain all the basic styles of calligraphic strokes.

The proper positioning for creating large-size calligraphy

In the past, there were a number of different calligraphic styles in use, known as **seoche** 서체, which all originated from China; each would be used according to the text and the situation at hand. An individual writer would have also had his or her own style, of course, and some Korean masters, such as **Kim Jeong-hui** (or **Chusa**), were even revered in China. There is also a tradition of Hangeul *seoche*, or calligraphy for Korean script.

Jeonseo is the oldest style and was promulgated as the official style by the Chinese Qin Dynasty emperor.

Yeseo is an angular and simplified version of *jeonseo*.

Haeseo is a formal letter style that originated during the Wei Dynasty of China. It has been very popular ever since.

Choseo is the cursive style for quicker and easier writing made after *yeseo*.

Haengseo is the combination of *haeseo* and *choseo*, and was used for more convenient writing.

Ceramics

Korean ceramics are famous worldwide, especially Goryeo celadon. The country's different ceramic styles are divided according to the techniques used in their creation, which are often era-specific, as well as by their patterns and forms, which define each piece's intended use. Historically, the most common styles are, in chronological order, comb-pattern pottery, stoneware, celadon, the *buncheong* wares, the white (blue and white) porcelains and of course, the utilitarian *onggi*, best known for its use in storing kimchi and other preserved foods.

An important point to remember is that the term "ceramics" can be applied to all clay utensils that have been processed by fire. This includes pottery (simple clay vessels), stoneware (a very hard, stone-like, greyish clay pottery) and porcelain (clay mixed with kaolin, with a feldspar-based glaze). China, by contrast, is the word for a tender kind of British porcelain, and is also a synonym for porcelain.

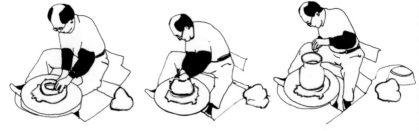

Togi 토기 is the first type of pottery ever found on the Korean Peninsula. The term denotes simple, unglazed earthenware fired between 600 ℃ and 700 ℃, with its name referencing the "comb" pattern seen on its outer surfaces. The first pieces were made from 6000 B.C. onward during the Neolithic period.

This humble style was followed by *dogi* 도기 pottery, which emerged during the Bronze Age. *Dogi* pieces are fired between 900 ℃ to 1000 ℃ and sometimes glazed, but free of pattern. It was only at sites associated with the Silla period (57 B.C.–A.D. 935) that we found *seokgi*, or stoneware, which is fired at 1100 ℃ by deoxidized firing.

Celadon, or *cheongja* 청자, is the first example of *jagi*, or porcelain, in Korea. It is made from fine white kaolin clay mixed with iron and then glazed with feldspar and iron, heated to 1300 ℃ by deoxidized firing. It was produced from the end of the Unified Silla period (668–935) onward, though the technique was improved under the Goryeo Dynasty (918–1392), hence the name Goryeo *cheongja*. The technique was borrowed from China, but Korea developed its own style, which has become widely recognized as one of the finest celadons. One of the more noticeable attributes is the thin, iron-based glaze that is almost transparent, giving the pieces their unique jade (blue-green) color. The celadon pieces also featured the elegant shapes associated with Korean aesthetics, as well as the 12th-century technique of filling inlaid patterns with pigments or clay before firing, known as *sanggam* 상감.

Buncheong ware 분청사기 was the second style of porcelain to be developed in Korea. It evolved from the declining form of celadon after the Mongolian invasion. A similar pale clay is used, on which a white slip (a water and clay mixture) is applied before glazing and firing. This technique was very popular in the 15th and 16th centuries, but declined after the Japanese invasion of 1592.

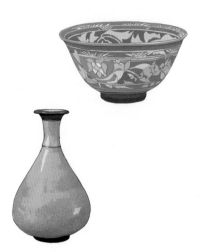

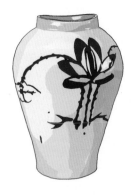

Baekja 백자 is the white porcelain typical of the Joseon period. It evolved during the end of the Goryeo period and catered to the Confucian-oriented aesthetics of the new dynasty. *Baekja* pieces are identifiable for their simple, beautiful porcelain made from kaolin clay with transparent feldspar glaze. Though production was first limited to pieces for the royal family, it was eventually produced in conjunction with the *buncheong* wares. From the 15th century onward, it was also produced alongside **cheonghwa-baekja** 청화백자, or white and blue porcelain, whose style was imported from China, and was very popular after 17th century. By the end of Joseon and the start of democratization, the simple and beautiful *baekja* pieces were widely produced, but were eventually replaced by the newly imported Japanese Kyushu wares.

Precious Artifacts

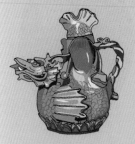

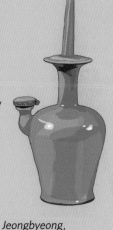

Fish-dragon-shaped
pitcher made of Celadon
from the Goryeo Dynasty
period, 12th century.
National Treasure No. 61

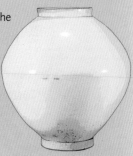

Maebyeong,
narrow-necked celadon
bottle with a peony
flower pattern from the
Goryeo Dynasty period,
13th century.
Treasure No. 346

Jeongbyeong,
a water vessel used in
Buddhist rituals from the
Goryeo Dynasty.
Treasure No. 344

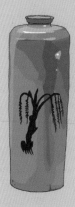

Celadon jar with a willow tree
design in an underglaze of
iron-brown from the Goryeo
Dynasty, 12th century.
National Treasure No. 113

White porcelain "moon jar"
from the Joseon Dynasty,
17th–18th century.
Treasure No. 1437

We have to mention the simple, humble, though beautiful and ubiquitous ***onggi*** 옹기, or black earthenware, still used to preserve kimchi and other food. Varied in shape and size, it can be called *dok*, ***hangari*** 항아리, or *siru* depending on its function, and often bears a striking dark brown glaze.

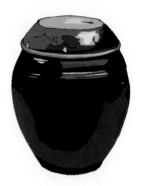

The kilns, or ***gama*** 가마, in which the pottery is heated are made of bricks covered with clay, and are almost completely sealed once the pieces have been placed inside. The intense heat is maintained over the course of several days with a wood fire. Kilns are still found in regions famous for their clay, such as the Gyeonggi region (Gwangju, Icheon) or the Jeolla region (Gangjin).

Dances

Korea has held on to a lot of the dance traditions that express the soul of the nation's culture. Most of them originated in dances performed during religious rituals, and they still bear traces of their shamanist or Buddhist origins. As time went on, the religious aspects were absorbed into the more artistic interpretation of the dances, which had been taken over by laypeople and professional performers, such as the female *gisaeng*, who brought them to the royal court. At the end of the Joseon Dynasty, after the 17th century, commoners started to enjoy these dances as well, witnessing them during street performances or at special feasts. These traditions had all but disappeared, until they were rediscovered, improved and redeveloped by a modern Korea in search of its cultural identity. They survive now in theatres, festivals and university student clubs.

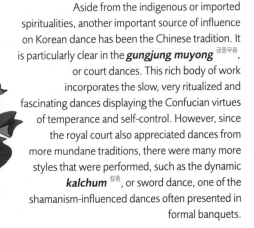

Aside from the indigenous or imported spiritualities, another important source of influence on Korean dance has been the Chinese tradition. It is particularly clear in the **gungjung muyong** 궁중무용, or court dances. This rich body of work incorporates the slow, very ritualized and fascinating dances displaying the Confucian virtues of temperance and self-control. However, since the royal court also appreciated dances from more mundane traditions, there were many more styles that were performed, such as the dynamic **kalchum** 칼춤, or sword dance, one of the shamanism-influenced dances often presented in formal banquets.

The commoners also had their own traditions, belonging to the **_nongak_** 농악 category of "farmers' music." Local troupes of musicians playing simple musical instruments (drums, gong, trumpet) would accompany communal farmwork to cheer up the peasants, or would perform for special rituals and festivals like Chuseok. The band leaders playing a small gong or *sogo*, could also dance along to the dynamic music performance. The performers would wear a whip-like tail on their hat that they would spin while performing in acrobatic movements (*sogochum* 소고춤). Although simple, they are a great display of life and energy.

Buchaechum 부채춤, or fan dance, was invented during the 20th century by Choe Seung-hui, who revived an old shamanist form of dance by incorporating ornately decorated fans into the performance. Young female dancers carry out their movements wearing colorful *hanbok* and manipulating the delicate yet eye-catching fans, evoking the grace of blooming flowers and butterflies.

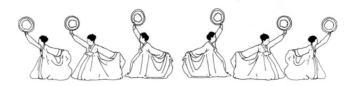

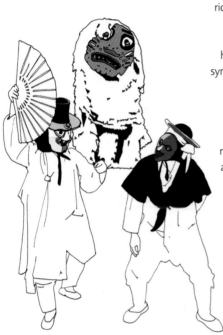

The ***talchum*** 탈춤, or mask dances, are a rich and complex part of Korean cultural heritage. They can surely trace their origin back to religious rituals where human and animal masks were used to symbolize the presence of spirits. Slowly, the practice evolved into an artistic performance. Until the 17th century, *talchum* was considered a strictly aristocratic form of entertainment that remained controlled by the royal court, after which point they became popular among commoners. The common performers found ways to use these cathartic dramas as a unique way to express social satire, as well as an outlet for both poetry and prosaic statements. As a result, the art form gained in popularity, which reached its peak at the end of 19th century.

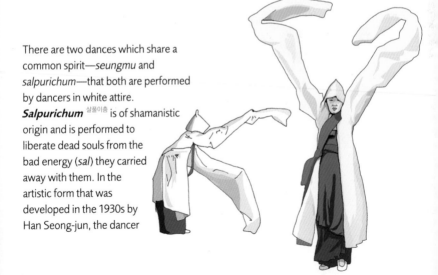

There are two dances which share a common spirit—*seungmu* and *salpurichum*—that both are performed by dancers in white attire. ***Salpurichum*** 살풀이춤 is of shamanistic origin and is performed to liberate dead souls from the bad energy (*sal*) they carried away with them. In the artistic form that was developed in the 1930s by Han Seong-jun, the dancer

uses delicate movements to express the sorrow and pains of life while playing graciously with a white scarf. **Seungmu** 승무, by contrast, comes from the Buddhist tradition and was used by mendicant monks to express the path to enlightenment to commoners. In it, a solo dancer wearing a robe with long sleeves and a peaked hat dances to a drum beat along seven dramatic episodes showing the liberation of the soul.

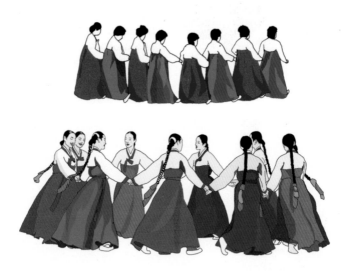

Ganggangsullae 강강술래 is a very old form of female dance, where young women from a village join in a big circle to dance and sing during the evening of the Chuseok festival. Originally dedicated to the moon and only performed by and for women, the dance was rediscovered by a scholar exiled in an island of Jeolla region in 1896 and named *ganggangsullae*.

Colors and Patterns

The colors and patterns favored by a culture are not only decorative elements; they also reveal the inner philosophy and spirit of the people. Korean colors used in folk artifacts are unforgettable: rich, bright and varied hues, soft and dream-like pastel tones—the Korean palette is multifaceted. Of course, there is a strong symbolism for each color used; they won't all fit every situation or object. The forms and patterns used in art reveal aesthetics based on pure lines and natural shapes.

The **buchae** 부채, or fan, was a commonplace object used in the past to cope with the summer heat. There are many traditional shapes and materials, the most common being paper. The two basic colors of the *taegeuk* (red and blue—heaven and Earth, respectively) are often combined in the form of a wave with yellow (man), giving the highly harmonious *samtaegeuk* form.

Dancheong 단청 is a very common array of basic colors used for building decoration: palaces, temples and shrines especially, but also for decorative items. Their symbolism, said to come from an old Northeast Asian tradition, is believed to be a reference to Taoist values. Yellow, red, blue, black and white are the basic colors linked with the five basic elements (with green being considered a variety of blue). From the Goryeo Dynasty (918–1392) onward, green, which was considered a "cool" color, was used in high places on buildings to compensate the hot sunlight, while red, a "hot" red color was used in lower, shadowy places (*sangnok hadan* theory). These practices also have a practical aspect: The paint helps protect the building's wooden surfaces from aging.

Bokjumeoni 복주머니 was a small purse used by women. Its typical shape evoked a seed-filled pomegranate, which was a symbol of wealth and happiness. These bags were made of silk or cotton and richly embroidered, making each of them a unique piece of art.

Bojagi 보자기, or wrapping cloth, was one of the many ways for women to express their artistic talents. The abstract **jogakbo** 조각보 is a patchwork piece of needlework made of cotton, silk or ramie pieces sewed together in a "cubist" fashion, giving the appearance of a Mondrian painting. This way of turning small pieces of otherwise unusable fabric into improvised compositions resulted in beautiful pieces of everyday art that now embody the aesthetics of Korean traditional craftwork.

There is another shape you'll see almost everywhere: **sumaksae** 수막새 (the roof-end tile design), which is as old as the Goguryeo Dynasty (37 B.C.–A.D. 668), and is still used in traditional buildings. This *giwa* (tile) decoration reproduces the image of a stylized flower, such as lotus or peony, or a *dokkaebi* monster face (a Korean folk creature), among other things.

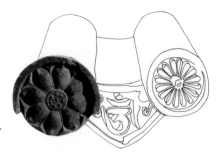

The latticework found on wooden doors and windows is another one of the aesthetic wonders of traditional Korean houses. The repetitive, geometrical pattern evokes Chinese ideograms, flower shapes or simply abstract forms in a simple yet elegant manner, a style that falls somewhere between the elaborate artistry of Chinese doors and the very abstract patterns of Japanese sliding doors. These Korean panels are made of carved or mounted wood with mulberry paper glued over top to protect from the cold, which allows sunlight to shine through and decorate the inside of the house with beautiful shadow and light effects.

The practice of adding special flourishes to everyday items also manifested itself in something so simple as the metal keyholes on furniture like chests, or on house gates. In Korea, these objects are often made in a special shape, the most common being butterflies, bats, flowers or the basic eight trigrams (*palgwe*).

Musical instruments

Korea has its own cheerful, elegant, unique music tradition. We can find three broad categories: court, religious and folk music. Of course, after more than 2,000 years of history, the once distinct genres grew to influence one another and many instruments are common to them all. Generally speaking, however, the court music is slow and quiet compared to the lively folk music.

Court music

Court music had two main categories: One was the music played for rituals and ceremonies, deeply influenced by Chinese court music, especially in the Tang and Sung Dynasties, which could be called ritual Confucian music. It was named *a-ak* 아악. The other sort included all the music played for entertaining the court and the aristocracy, and shared elements with the former and also with commoners' music.

The music played at Jongmyo, the royal ancestral shrine, is called Jongmyo Jeryeak, and has been recognized by UNESCO as a form of intangible cultural heritage. It originated as a court banquet music before becoming a codified corpus for the funerary ceremonies under King Sejo's reign (15th c.).

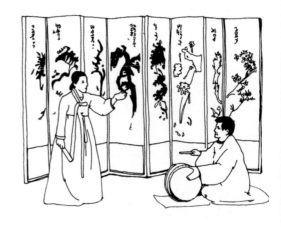

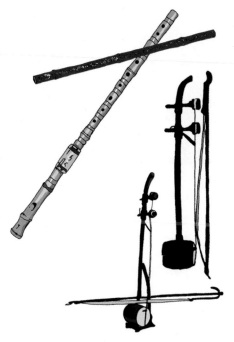

Aristocratic music favored string and wind instruments, considered to be more refined. Among them were the **daegeum** 대금, a large transverse flute; the **tungso** 퉁소 and **danso** 단소, two bamboo flutes; or the intense two-stringed fiddle **haegeum** 해금.

The **gayageum** 가야금, or 12-stringed Korean zither, is said to originate in the old Korean Gaya kingdom. It is a very refined example of an aristocratic musical instrument, for which *sanjo*, or solo pieces, were composed at the end of the 19th century.

Other famous zithers are the **geomungo** 거문고, or 6-stringed zither played with a stick, and the **ajaeng** 아쟁, a 7-string instrument played with a bow.

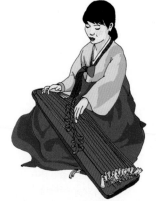

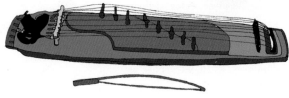

The ceremonial *a-ak* style of music almost disappeared along with its instruments, such as this **jingo** 진고, a large drum nowadays only used for the Jongmyo Shrine ritual or other special concerts.

Religious music

Korean religious music is mainly made up of Buddhist and shamanist compositions. Both have specific characteristics, but are highly influenced by folk and court music. Their musical instruments are also very similar. Buddhist music mainly uses solemn and mystic percussion instruments made of wood, leather or metal, such as the huge temple bell known as a *beomjong* (see "Buddhist Temple" on p.188). The semi-shamanist dance *seungmu* used a large hanging drum, or *seungmubuk*.

Folk music

The eight-holed conical oboe, **taepyeongso** 태평소, is used in both shamanist and Buddhist ceremonies.

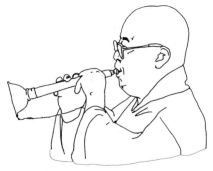

Nongak, or farmer's music, was played for festivities and also while some work was carried out in the fields. There were various instruments, but the music mainly revolved around percussion rhythms that produced a vibrant and cheerful atmosphere. The instruments and tunes are quite similar to *musogak*, or shaman's music.

Samullori

Samullori 사물놀이 is folk music that incorporats at least four basic instruments: *buk*, *kkwaenggwari*, *janggu* and *jing*.

Buk 북

A *buk* is a drum used in folk music, which is easy to carry around and produces a deep sound. In the past, they were made by emptying out the inside of a tree. Nowadays, they are usually made of wood planks pieced together.

Kkwaenggwari 꽹과리

A round brass instrument that is 20 centimeters in diameter, it has a string to hold it around the performer's wrist and is played with a small stick.

Janggu 장구

A typical Korean percussion instrument that looks like an hourglass, the left side of the *janggu* is covered with cowhide (beaten with one's palm), and the right side is covered with horsehide (beaten with a slim bamboo stick).

Jing 징

A brass percussion instrument with a bottom measuring about 36 centimeters in diameter, a *jing* produces sublime and soft tones when struck with a stick whose tip is wrapped in thick cloth.

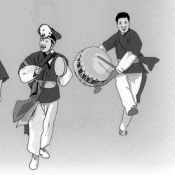

Songs

Korean music has its own unique features, although one may find similarities with Japanese music and deep influences from Chinese traditions. We have already seen the court and aristocratic forms of traditional music, as well as the *nongak,* or farmers' music, which included the now very popular *samullori* percussion ensemble. Korean lyrical forms too are much more popular, from *pansori* to K-pop. Let's take a look at some of the songs that rock Korea!

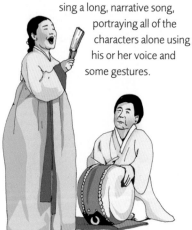

Pansori 판소리 is sometimes called "Korean opera," although it is completely different from the European style. It is a popular performing art that slowly evolved into its present form in the 18th century. A solo performer, female or male, called a **sorikkun** will stand and sing a long, narrative song, portraying all of the characters alone using his or her voice and some gestures.

A fan is waved to illustrate the start of a scene and opened to signify a change of section. A drum player, or **gosu**, provides the rhythm and some verbal encouragement, **chuimsae**, similar to the function of *olé* in flamenco.
Of the 12 "plays," or *madang*, only five still exist today: "Heungbuga," "Jeokbyeokga," "Sugungga,"

"Simcheongga" and "Chunhyangga," with the final two ("Story of Simcheong" and "Story of Chunhyang") being especially famous.

The movie *Seopyeonje* (1993) by Im Kwon-taek is a good introduction to this unique genre, which in 2013 was granted UNESCO designation as a Masterpiece of the Oral and Intangible Heritage of Humanity.

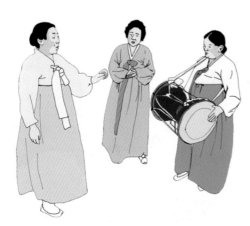

Minyo 민요 is a word categorizing all the folkloric songs. There are hundreds of them that have originated from different regions of Korea. They have had a strong influence on modern Korean poetry, and even on modern Korean songs, or **gayo** 가요.

The most famous *minyo* song is without doubt **"Arirang** 아리랑**."** Its sad lyrics speaking of separation and isolation seem to embody all the *han*, or Korean bitter pathos. The origin of the song is unknown, although some suggest that one possible source is the fall of the Goryeo kingdom and the exile of its elites to the provinces. Each area has its own rendition of "Arirang," but the most commonly heard version is from the Gyeonggi region.

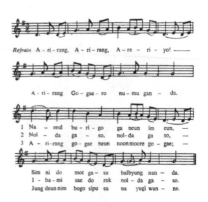

Refrain A - ri - rang, A - ri - rang, A - ra - ri - yo! ——

A - ri - rang Go - gae - ro nu - mu gan - da.

1 Na - reul bu - ri - go ga neun im eun, —
2 Nol - da ga - so, nol - da ga so, —
3 A - ri - rang go - gae neun noon moore go - gae; —

Sim ni do mot ga - su balbyung nan - da.
I - ba - mi sae do rok nol - da ga - so.
Jung deun nim bogo sipu su na yugi wan - ne.

Another genre not to be missed is the **teuroteu** 트로트, which is also called *ppongjjak* for its jerky rhythm. Its name comes from the word *trot*, an abbreviation for foxtrot, a dance whose rhythm is said to have inspired the style. Since it may have been a Japanese import from the colonial time, it is sometimes criticized as not purely Korean, but it is still heard nowadays and had a huge influence on contemporary Korean pop songs (*gayo*). Famous singers of the 1970s and '80s *gayo* such as Patty Kim are still very popular nowadays among people of the older generation.

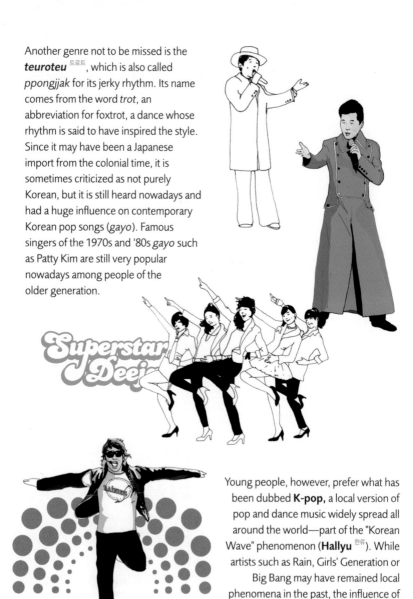

Young people, however, prefer what has been dubbed **K-pop,** a local version of pop and dance music widely spread all around the world—part of the "Korean Wave" phenomenon (**Hallyu** 한류). While artists such as Rain, Girls' Generation or Big Bang may have remained local phenomena in the past, the influence of K-pop acts outside the peninsula has been more pronounced in the years since 2000.

122

Scholar and Court Paintings

The Korean painting tradition has a long history spanning multiple dynasties, but because the works from the Joseon era were created more recently and were thus easier to conserve, they are better known than most. Though deeply influenced by the Chinese schools for their styles, themes and techniques, Korean painting eventually developed its own distinct identity. With the exception of folk painting, or *minhwa* (anonymous), Korean traditional painting was art that, for the most part, was made both by and for the ruling classes. Painters were employed by the government and produced mainly for the royal court, but the noblemen, and even the king himself, also enjoyed practicing the art because it embodied the ideals and values of the literati.

Sansuhwa 산수화, or paintings of mountains and water, was the most popular genre and is best described as landscape painting. At first, the works from this era demonstrated influences from the Chinese Ming Dynasty style of the Zhe school. Fifteenth-century painter An Gyeon and his disciples, for example, painted idealized landscapes of imaginary places until the middle of the Joseon Dynasty. Then came the influence of the Chinese South School, which popularized a more realistic *sansuhwa*. Jeong Seon,

the forerunner of this *jingyeong* (real view) *sansuhwa* in Korea, was to be followed by such masters as Yun Du-seo, Gang Se-hwang and Kim Hong-do.

This painting genre was highly codified and there were classical topics inherited from the Chinese tradition: the *sosang-palgyeong* (eight views of the rivers Hsiao and Hsiang), the *sasi-palgyeongdo* (eight views of the four seasons) and the *jeokbyeokdo* (paintings of the Red Cliff, setting of a famous battle in China). The "Real View," or realistic school, developed alongside the trend of producing travelogues, like the *Geumgangjeondo*, or *Views of Mt. Geumgangsan*.

Pungsokhwa 풍속화, or "genre painting," was an additional style that was developed alongside the realistic *sansuhwa* paintings: realistic scenes painted on concrete subjects and sketches of the everyday lives of commoners. The most famous artists of this genre were **Kim Hong-do** (1745–unknown), who produced 25 drawings in the style; **Sin Yun-bok** (1758–unknown) who was known for sensual scenes (*chunhwado*); Kim Deuk-sin (1754–1822); and **Yun Du-seo** (1668–1715).

State-sanctioned paintings were also characterized by the practice of producing formal portraits that were supposed to express the virtues of moral teaching. Such was the case in the more idealized paintings of the **gosainmulhwa** 고사인물화, or portraits of the famous sages of old times; scholars were represented in situations inspired by classical texts or sutras, portrayed in a spirit of instruction: a scholar contemplating the water while resting on a rock or with their foot in the water of a mountain stream, for example. The royal office also produced a lot of documentary paintings to serve as the chronicles of the lifestyle, rituals and historical events associated with the

members of the court. Court painting also included more decorative styles painted by lower-ranking artists; many scholars view these paintings, which include flowers, ideograms, birds, and plants, 12 symbols of longevity, as the origin for the themes of many later folk paintings (*minhwa*).

Another popular genre was the paintings of animals, called **yeongmohwa** 영모화. At first, the term *yeongmo* only referred to the feathers of birds, but this symbolism was eventually extended to hair in general, therefore applying to all animals, particularly those that represented spiritual guards against diabolical spirits.

The end of the Joseon Dynasty marked the arrival of realistic Western painting, which combined with the South School of China to give two styles: *wonche* and *sasaeng*. These styles began to decline toward the end of the dynasty, but their popularity had a huge impact on folk painting. The representative painters of this technique were Jang Seung-eop, Sin Saimdang, Kim Hong-do and Gang Se-hwang.

Four Gracious Plants

Many of the literati painters had a predilection for paintings of the "Four Gracious Plants," or *sagunja* 사군자: plum tree, orchid, chrystanthemum and bamboo. These paintings were often combined with poetry, representing the four seasons and the cardinal virtues of the Confucian gentleman. After supposedly arriving on the peninsula from Song China, *sagunja* became a codified genre around the middle of the Joseon era.

Spring

Plum tree (*mae* 매)

An early spring flower known for overcoming the coldness of late winter, the plum tree represents the sage's ongoing struggle against immorality and injustice.

Summer

Orchids (*nan* 난)

At home deep in the mountains, the orchid disseminates its soft, delicate scent over great distances, making it a symbol of the elegance and virtuous dignity a Confucian gentleman should possess.

Autumn

chrysanthemum (guk 국)

The chrysanthemum's long and late-season flowering period symbolizes the integrity and indestructible principles of the scholar; for women specifically, the flower symbolizes preserved virginity.

Winter

Bamboo (juk 죽)

The plant's upright firmness and everlasting green foliage have made it an additional symbol of integrity.

Folk Paintings

Folk painting, or *minhwa* 민화, is probably one of the most representative and original expressions of Korean art. You'll see its motives everywhere in modern Korea, since these works have managed to penetrate the collective psyche and represent much more than a tradition of the past. The images of this painting style come from the most ancient of Korean folklore, mixing local shamanism and old Taoist and Buddhist influences with Confucian morality and Chinese legends, as well as history, myth and literature. This integration into common culture may be why these patterns survived to a certain extent nowadays; the *minhwa* was an anonymous style of painting that mainly flourished between the 18th and 20th centuries, but it had to wait until recent years to be recognized as art.

It is impossible to trace the exact origin of folk painting in Korea; what is now described using the term *minhwa* has undergone a tremendous development from the 18th century, when the common people, due to better material conditions and a rising bourgeois class, started to wish for a better life. They were seduced by the symbolism of the paintings displayed in court and noble houses, which were offered as gifts of goodwill for the New Year or on birthdays, or hung on walls to bring good fortune. The *minhwa* could be seen as an imitation of more elaborate and refined court and literati paintings, turned into anonymous, mass produced craftworks—a more freestyle version of a Chinese-influenced official painting. What the folk paintings lacked in technique they made up for in creativity.

Hojakdo 호작도, or magpie and tiger paintings, are one of the most famous styles of *minhwa*. Historically, the tiger was a propitious figure bringing luck and warding off evil spirits. In *minhwa*, it took a more satirical role, often represented with a magpie or a rabbit. Works in this genre often have at least three different functions: to wish good luck, to present satire and to add decoration (many *minhwa* were used as folding screens or wall papers), not to mention the mere contemplative, aesthetic aspects. Some other pictures have even ritualized functions, while others serve more of an educational purpose in reflecting the values of the Confucian aristocracy. This practical dimension is a characteristic of the genre.

Other themes clearly borrow from the court and scholarly painting styles, such as the *sipjangsaengdo* 십장생도, or paintings of the 10 longevity symbols. They are related to the paintings placed in the area behind the royal throne (*irworobongdo*). Later, they were exchanged between nobles and ministers as gifts for a person's 60th birthday, and eventually became popular among commoners for their symbols: sun, deer, tortoise, water, rock, pine tree, crane, elixir of life, bamboo and clouds.

In *minhwa*, there are numerous examples of flower paintings: chrysanthemums, peonies, plum trees, pomegranate and peach, among many others. Here, the decorative aspect met the very auspicious symbolism of the subject, mainly fertility, wealth and longevity.

Animals, along with plants, were the most represented theme. The genre may have originated in the *yeongmohwa*, or bird painting, of the literati, but the term was later expanded to include different kinds of animals with propitiatory symbolism such as the dragon, phoenix (longevity, happy marriage), mandarin duck (fidelity in a couple), crane (everlasting fame and fortune), carp (success), deer and rabbit. They helped people express their wishes and desires, and were thought to guard people from evil spirits.

Munjado

The eight ideograms depicting basic Confucian virtues

효孝
hyo, or filial piety

제悌
je, or brotherly love

충忠
chung, or loyalty

신信
sin, or trust

예禮
ye, or propriety

의義
eui, or
righteousness

염廉
yeom, or
integrity

치恥
chi, or
restraint

Traditional

Women's Costume

The traditional female costume has evolved through the centuries, first incorporating influences from Chinese attire, then from Mongolian dress under the Yuan Dynasty. During the late Joseon Dynasty, it acquired the appearance we can still witness today: a long and large skirt tied above the breast covered by a very short bolero. Also called by the generic term *hanbok*, it is a symbol of Koreanness even though it is now only worn on special occasions. Some contemporary designers are introducing elements of the *hanbok* to their modern creations, giving new life to the traditional outfit. There are even present-day versions of *hanbok* adapted for eveyday use.

This is the typical **hanbok** 한복 (literally: Korean costume) worn in the past by upper-class married women, whereas commoners had a simpler white dress. On formal occasions, noble-women and court ladies had more luxurious and formal attire.

Dongjeong, or white strip

Git, or collar

Goreum, or tie

Chima 치마, or skirt

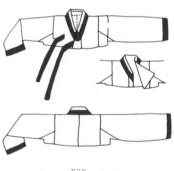

Jeogori 저고리, or bolero

Beoseon 버선, or socks

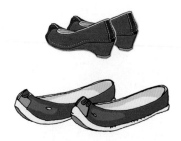

Danghye, or silk and leather embroidered shoes

Outer jacket of a hanbok

During the Joseon Dynasty, under the rule of neo-Confucian values emphasizing female humility and virtue, women of the ruling classes were not supposed to leave their house alone. They even had to wear a sort of coat covering their head like a veil, called a ***jangot***.

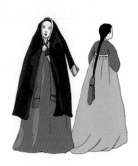

Jangot, or veil

Adornments

Among the regular accessories worn by the upper-class women, there were the ***norigae*** 노리개, or colorful knots made of silk threads decorated with jade, coral and other semi-precious pendants. The *norigae* was hung at the front of costume, on the *goreum* or the *chima*. It was also accompanied with a small knife, or *eunjangdo*, whose primary function was to help the woman defend herself, or even kill herself if her virtue had been violated. Over time, it became a mere decoration.

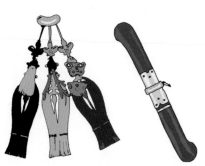

Norigae, or decorative pendants

Eunjangdo, or silver knife

Hairstyles + Accessories

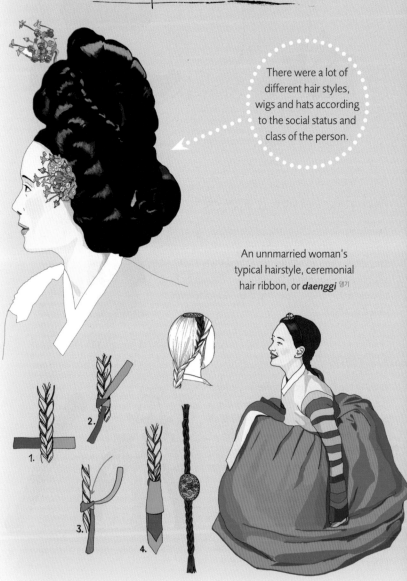

There were a lot of different hair styles, wigs and hats according to the social status and class of the person.

An unnmarried woman's typical hairstyle, ceremonial hair ribbon, or **daenggi** 댕기

1.

2.

3.

4.

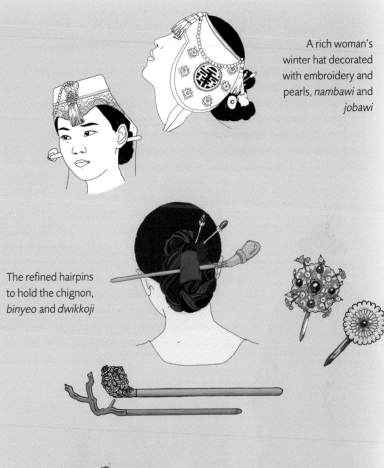

A rich woman's winter hat decorated with embroidery and pearls, *nambawi* and *jobawi*

The refined hairpins to hold the chignon, *binyeo* and *dwikkoji*

The small black jeweled hat (*jokduri*) was worn by married noblewomen on ceremonial occasions, but there was one day in each commoner's lifetime when they had the right to wear it as well: on their wedding day.

Men's Costume

Men's outfits were generally simpler than those of women in both style and color. There was a tendency to have few distinctions between the types of the clothing worn throughout society during the Joseon Dynasty. Differences in social standing and status were mostly marked by a person's hat (a tradition that dissolved at the end of the Joseon Dynasty) and decorative items, as well as the quality of each garment's materials (especially for shoes) and, of course, the cleanliness!

The court people, including the king and all the government officials, from the civilians to those with military rank (**yangban** 양반, or aristocrats), all wore brightly colored outfits. The different garments were actually very similar in shape, distinguishable from one another only by the colors and the decorations, which indicated a person's status. Officials wore long coats covering their hands and firm, loose-fitting belts that symbolized their rank. This clothing was inspired by Chinese fashion, especially after the Mongolian Yuan Dynasty.

For kings and other high-ranking officials, an embroidered plastron worn on the chest was a way to express an individual's rank and order. The tigers was a symbol of the military order, while the crane was a symbol of the literati officials.

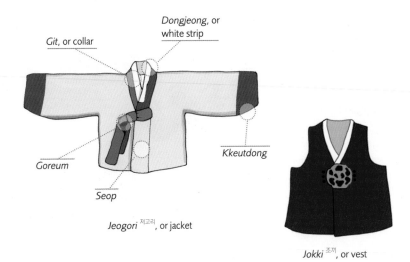

Git, or collar

Dongjeong, or white strip

Kkeutdong

Goreum

Seop

Jeogori 저고리, or jacket

Jokki 조끼, or vest

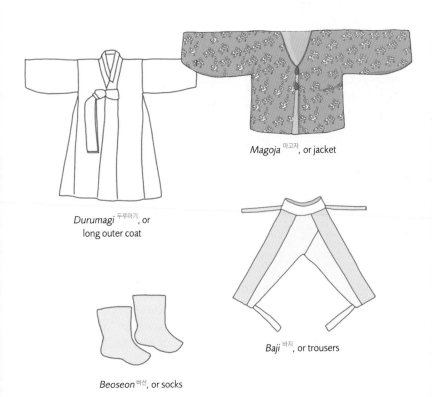

Durumagi 두루마기, or long outer coat

Magoja 마고자, or jacket

Beoseon 버선, or socks

Baji 바지, or trousers

Whereas the ordinary people could afford nothing more than the *jipsin* 짚신, or straw shoes, and sometimes a set of wooden ones (*namaksin*) for the rainy season, rich people had strong leather and metal shoes, and officials wore leather and fabric boots. The appearance of rubber shoes in the 1920s (*gomusin* 고무신) initiated the disappearance of these traditional shoes.

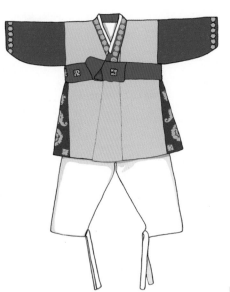

Grey and dark colors were preferred by monks, while bright colors were the privilege of children, young people (especially on their wedding day) and officials. Older people favoured pastel colors such as pink or light blue, a trend that is still seen today.

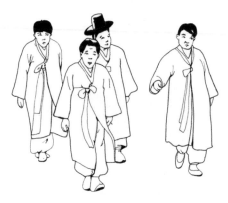

Before the start of the Joseon Dynasty, Korean people became known in China under the name **Baegeui Minjok** 백의민족, or the People Wearing White Clothes. White clothing was favored among both lower and upper classes as a symbol of purity and humility. By the middle of the Joseon Dynasty, however, dressing in this way was regularly forbidden by law because such attire was supposed to indicate mourning and didn't allow class distinctions as colors would have done. In the 19th century, however, they became widely used when the dyeing process became expensive for many people. White *hanbok* were once again forbidden by law in 1906 and under Japanese colonial rule.

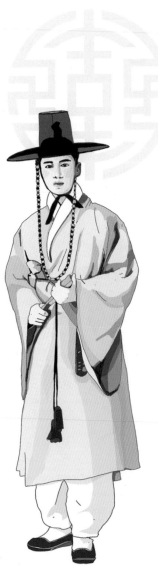

Men's Hats

During the Joseon era (1392–1910), Koreans used to wear hats, not only to protect themselves from rain, snow or sunlight but also to mark their distinctive social class. Hats were a useful way to recognize the position or occupation of a person. These hats with an official significance were called *gwanmo*.

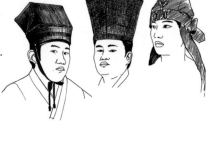

Among them, the most symbolic of this era is the **gat** 갓, a large-brimmed black hat worn only by the nobility, or *yangban*, during the early Joseon era. Later, this restriction was relaxed and common men were allowed to wear it also, although their *gat* was smaller in size and was ornamented with different decorations, such as jade, amber, coral, crystal pieces of cloth, which could be attached to the *gatkkeun*, or string.

Each was made of horse hair and bamboo strips that had been painted black.

All the men had to wear long hair until Japanese rule changed this practice at the beginning of the 20th century. Young boys wore their long hair in plaits, which would last until either their wedding ceremony or when they were entering an official charge; at this point, they would tie their hair in a knot (**sangtu**) on the top of their head, a symbol of one's coming of age.

To wear a *gat* or other *gwanmo*, one had to first put on a **manggeon**, a band of sorts, wore around the *sangtu* to secure the hat in place and also to absorb sweat. The *manggeon* was also made of horse hair and decorated differently from class to class.

Tanggeon, or skull cap, was another common accessory of the Joseon era. It was used by the nobility as a support at the base of a *gwanmo* or to cover the *manggeon* at home when not wearing a hat. People from the *jungin* class (or middle class, mainly merchants) had the right to wear it in place of the *gwanmo*.

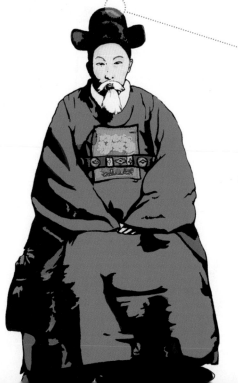

Samo was a black hat worn by scholars and government military officials. It had been introduced in Korea in 1387 following the custom of the Chinese Ming Dynasty.

This hat, **jeongjagwan**, was named after the Jeong Hyeon brothers, Confucian scholars of the Chinese Sung Dynasty. As we can guess, it was worn by Confucian scholars. Another type of hat worn by Confucian scholars in everyday life was known as the **dongpagwan**. During special occasions, such as the national official examination, memorial services or when going to Confucian schools, they wore the **yugeon**.

Jeollip is the general term for the hats worn by soldiers and military officials. For the common soldiers or junior officers, it was called *beonggeoji*. The *jeollip* worn by officers was made of black wool, and was decorated with *sangmo* (a feathered, decorative string) and occasionally with *milhwa* beads made of yellow amber.

Myeonryugwan was a ceremonial crown worn by the king.

Gulgeon was a white, hemp-based hood worn by mourners. It is still used nowadays for funerals.

Satgat was a large, cone-shaped hat made of oiled paper or bamboo that was used as a protection from the sun. It was made famous by the 19th-century wandering poet Kim Rip who used to wear it and took its name as a pen name: Kim Satgat.

Is it this long history of hats in Korea that has caused Koreans young and old to still love to wear newsboy and baseball caps, tennis visors, Panama hats and the like?

Martial Arts

Korea has very old traditional "sports" such as martial arts and wrestling, all of which are still widely practiced. Of course, when many of them were first established (some over 2,000 years ago), they were not enjoyed merely for fun or health concerns like they are nowadays. Martial arts were a way to achieve a full control of one's mind and body, as well as being a means of defending oneself. More generally, according to the few primary resources that exist on the topic (tomb paintings, Chinese and Korean records) and what has been observed in other similar cultures, it appears that these pastimes initially had a more ritualized meaning, being performed for special religious occasions.

Archery (gungsul 궁술)

This is a very traditional sport where Koreans still excel. The most common form in the past involved a well-arched bow and feathered arrows that have to be shot at a target placed far away. This art was and continues to be practiced in special open-air grounds, one of them being just behind the Sajikdan Altar in Seoul. This sport, with roots that are most likely to be found in military and hunting activities, is said to have been especially popular during the Mongolian occupation of the Korean Peninsula during the Goryeo era.

Taekkyeon 택견

Taekkyeon is theorized to have been stemmed from *subak*, an old type of martial art, although there is little evidence to support this claim. Some say it was practiced by the Hwarang elite fighters of the Silla kingdom (57 B.C.– A.D. 935), but its mention in any historical text comes from the book *Manmulbo*, written around 1790. As a martial art, it shares many common points with taekwondo, especially the focus on kicks and hand movements. The motions of *taekkyeon* are less abrupt in nature, emphasizing a constant, dance-like fluency that is somewhat reminiscent of capoeira or kung fu. In addition, kicks are designed to push the opponent either out of the ring or to the ground, not to harm them—another difference from

taekwondo. The practice almost disappeared during the 20th century before being classified in 1983 as an Intangible Cultural Heritage No. 76 thanks to Master Song Deok-gi (1893– 1987). In 2007, its practice was finally unified under one central organization and in 2011 *taekkyeon* joined UNESCO's Representative List of the Intangible Cultural Heritage of Humanity. Practitioners wear outfits that are similar to the garments worn by people during the Three Kingdoms era (Goguryeo tombs paintings).

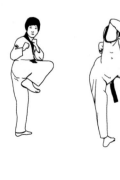

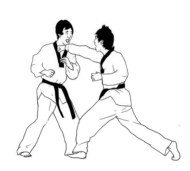

Taekwondo 태권도

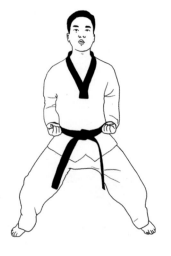

Taekwondo is a free-fighting sport involving bare hands, fists and foot kicks that, despite being largely designed for self-defense, can be used to severely injure one's opponent. The practice promotes a deep, spiritual meaning that can still be found in multiple aspects of the discipline: in the importance of breathing when training one's energy, or *gi*; in the symbols behind the uniform, or *dobok*; and in the esoteric forms of the *poomsae*. The **poomsae** 품새 are the courses of basic, successive stances for offense and defense that one must master to attain the different belts and acquire the *dan*, or defferent levels of black belts. Taekwondo was first developed in the 1940s as a combination of *taekkyeon* and other martial arts. The Korea Taekwondo Association was founded in 1961 and in 1994 the practice was selected as an official sport for the 2000 Sydney Olympics.

Ssireum 씨름

Ssireum is a form of traditional wrestling that falls between Mongolian-style wrestling and the much codified Japanese sumo. It is practiced on a sand ring like the latter, and the two opponents, who are typically quite "solid" men, wear only short pants and a belt called a *satba* around the waist. They grasp each other by that belt, shoulder to shoulder, and try to send the opponent to the ground. Wrestling is obviously one of the world's oldest sports, evidenced by its historical presence in many different countries. During the Joseon era, it became a folk sport and was also a way for peasants to spend their leisure time in winter—arranging face-offs between the men of two villages in large contests—hence its deep grounding in rural Korea even nowadays. The Korea Ssireum Association was founded in 1927, and the practice became a professional sport in 1983.

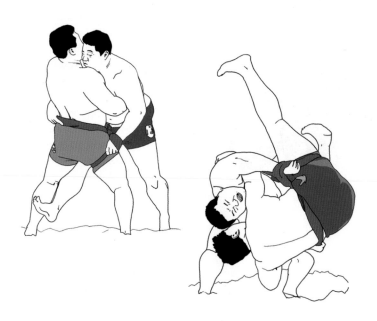

Everyday objects of the old Days

When travelling in the countryside, visiting folk museums and antique shops and looking at old pictures, you'll regularly see a selection of obscure objects from the past that might be otherwise unknown to you. Since they exist as a part of the Korean collective imagination, it is worth introducing them briefly .

Straw shoes

These traditional straw shoes (*jipsin* 짚신) were made of straw rope or other materials such as hemp, rush and cattail, among other things. They were light, well ventilated and cheap, making them very common in the past. *Jipsin* were worn with bare feet or sometimes with traditional socks, and were slowly replaced by rubber shoes (*gomusin* 고무신) during Japanese colonial times.

GOMUSIN ◀ ·······

Hand mill

This hand mill (**maetdol** 맷돌) operated by one or two people is made out of stone and is used to grind grains and water-soaked beans. The latter becomes the paste that is produced generally used to make *dubu*, the Korean tofu.

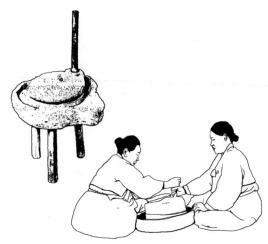

Cauldron

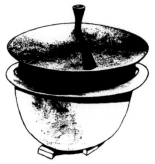

This big metal cauldron (**sot** 솥) typically stands in the kitchen over the fire-hole also used for the *ondol* heating system (the larger versions are called *gamasot*). It is used to prepare rice, soup and cattle feed.

Winnow

This traditional winnow (**ki** 키) was used to toss grain in the air and blow out the unusable husk and chaff. It was made out of bamboo strips or willow branches.

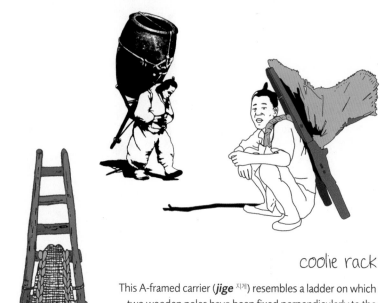

coolie rack

This A-framed carrier (*jige* 지게) resembles a ladder on which two wooden poles have been fixed perpendicularly to the frame to support the load. A loosely woven basket (*balchae*) made of bamboo or bush was sometimes added to contain the load. There was also a stick (*jige jakdaegi*) to help prop up the carrier when it stood on the ground. This device was commonly used by coolies and farmers to transport big loads, with classic versions still found in the countryside and modern versions in the nation's construction sites.

Smoking pipe

The use of the smoking pipe (*dambaetdae* 담뱃대) is said to have been introduced to Korea by Japan in the 17th century, along with tobacco. It was made up of a bamboo shank, a metal mouthpiece and a burning bowl made of metal or ceramic.

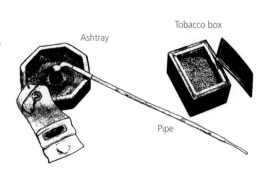

Ashtray

Tobacco box

Pipe

Wrapping cloth

This is a Korean wrapping cloth (***bojagi*** 보자기), usually made of patchwork. It emerged when, due to social codes that often left them secluded in their quarters, high society women took on embroidery projects using patchwork cloth as a way to pass the time. Made using pieces of different fabrics—the most precious ones being the hemp cloth and silk—these patchwork creations embodied the female spirit of these times. The final product was used to wrap different things, from goods bought at the market to lunches being eaten outside the home. This very simple but beautiful object could be turned into such varied tools as a handbag, food cover or mat, and is still commonly used today.

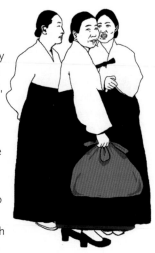

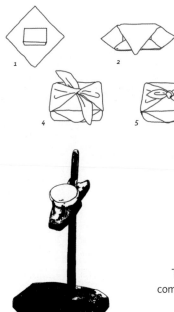

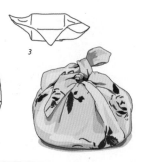

Oil lamp container and stand

This type of oil lamp (***deungjan*** 등잔) was a common form of lighting equipment until the introduction of electricity.

House

What we call a *hanok* ^{한옥} is a term referring to traditional style Korean housing. The word was coined after liberation from Japan and covers a large variety of types, from the simple thatched-roof houses of commoners to the large, multi-building estates of aristocratic families. Although it is quite difficult to make generalizations across an area so open to creative interpretation, we can find different categories depending on the social class, region and environment (rural vs. urban).

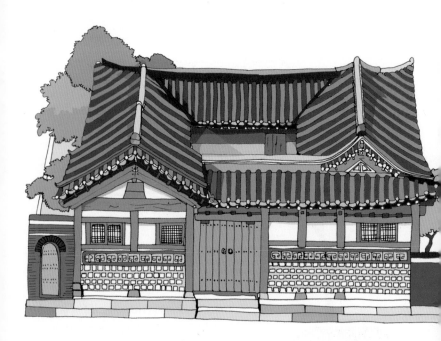

The urban hanok

Here is an example of the urban *hanok* that first appeared in large cities in the 1920s. Because they were limited by the small size of land lots that had been distributed along narrow alleys, these houses developed a style based on the traditional *hanok* structure, which in the past had usually faced inwards around a central yard. At the time, many of these new houses were topped with ceramic roofing tiles, like those belonging to aristocrats, but were also found on the homes of families that were members of the new bourgeoisie. The *chae* 채, or quarters, which used to be separated in the noble house, are linked together in the urban *hanok* as rooms (*bang* 방) to make a joined structure, often in a square shape.

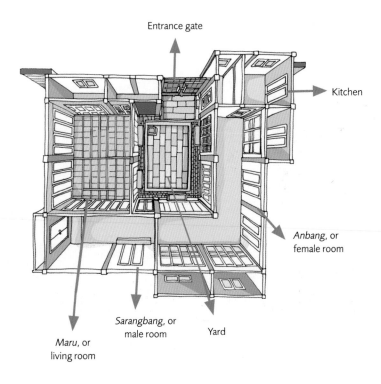

Entrance gate

Kitchen

Anbang, or female room

Sarangbang, or male room

Yard

Maru, or living room

Country houses

The grand estates of aristocratic families could be as large as 99 *kan* ^간 (a traditional measure between two columns), with the royal family being only party authorized to build larger palaces. These estates usually included different quarters for men, women and children, and servants (which may or may not be linked), and were centered around inner yards. Dwellings of more humble families had the same elements but in smaller number and size, often linked all together. This design could result in different sorts of shapes, depending on the region.

The northern regions and more mountainous areas tended to build structures that closed in on themselves like a square, or ㅁ shape (the Hangeul character *mieum*). Central regions like the Gyeonggi region had more variations in their housing styles, such as a more open ㄱ (*giyeok*) shape, while ㅁ (*mieum*) and ㄷ (*digeut*) were also common. The southern region featured a very open ㅡ (*yi*) shape to encourage airflow. Regardless of the shape of the house, all properties included a wattle-and-daub wall that enclosed the house, yard and garden.

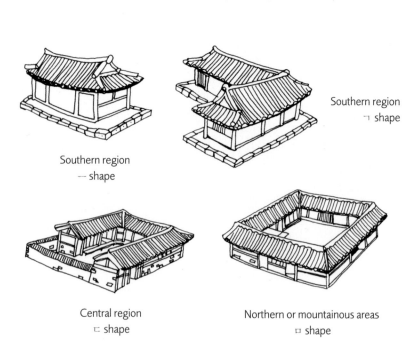

Southern region
— shape

Southern region
ㄱ shape

Central region
ㄷ shape

Northern or mountainous areas
ㅁ shape

Thatched cottage

Until recently, the **chogajip** 초가집, or thatched-roof house, was a sort of dwelling occupied by commoners in rural and urban environments alike. This type of house could vary in shape depending on the wealth and size of the family, but in the northern regions tended to be constructed in more of a block shape as a means of protecting families from the cold. Most of these houses disappeared with the New Village Movement, or Saemaeul Undong, launched by the President Park Chung-hee in the 1970s for the modernization of the country. As a result of this movement, the thatched roofs were replaced by brightly colored slates.

Materials

Traditional materials in Korea included daub (yellow loess and straw) covered with plaster for the walls; wood for the support beams, doors and windows; oiled paper for the heated floor; paper instead of glass on windows; and tiles for the more expensive roofs. Brick was rarely used before the 20th century, and was reserved to royal buildings when used.

Gentlemen's Quarter

The room of the man of the house was called the *sarangbang* 사랑방. It was a living, working and entertainment area, used by the master to sleep, study, work, practice calligraphy, play music or games with friends, read books and receive guests and sometimes female entertainers (*gisaeng*). Though the word *sarang* may suggest that the name translates as "love room," it actually means "reception room."

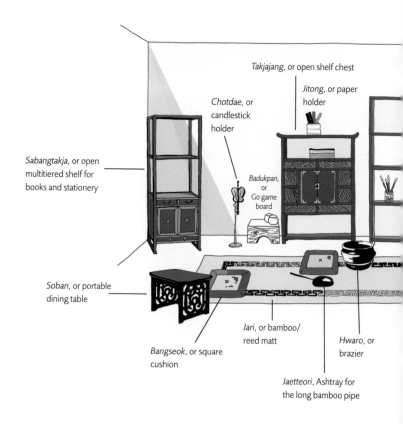

Takjajang, or open shelf chest

Jitong, or paper holder

Chotdae, or candlestick holder

Sabangtakja, or open multitiered shelf for books and stationery

Badukpan, or Go game board

Soban, or portable dining table

Jari, or bamboo/reed matt

Hwaro, or brazier

Bangseok, or square cushion

Jaetteori, Ashtray for the long bamboo pipe

For aristocrats and anyone with a large mansion, it was not only a room but sometimes a separate building, a *sarangchae*, which could potentially be divided into two parts: one close to the women's section, the inner *sarangbang* (*ansarang*), and the other close to the entrance, the outer *sarangbang* (*bakkatsarang*). It sometimes had a small door opening directly onto the street to discreetly receive guests.

As one can see, the room was furnished in a simple and elegant manner, including all the items necessary for the Joseon era gentleman's life and work. Each item symbolized the **seonbi** 선비, or scholar class, including the scrolls or paintings that were sometimes hung on the walls. The master of the house would typically sit in this room to receive his guests. Sitting cross-legged on the *boryo* and behind the desk, called *seoan*, or the *gyeongsang* reading table, the positioning of the furniture between him and the guest symbolized his role as the host.

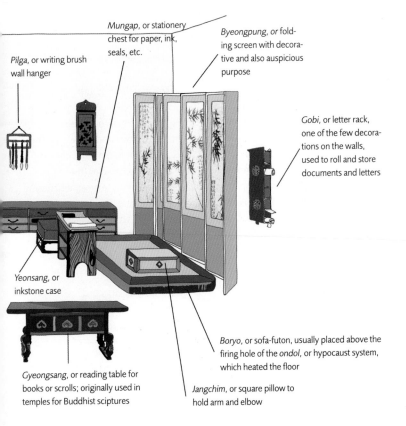

Mungap, or stationery chest for paper, ink, seals, etc.

Byeongpung, or folding screen with decorative and also auspicious purpose

Pilga, or writing brush wall hanger

Gobi, or letter rack, one of the few decorations on the walls, used to roll and store documents and letters

Yeonsang, or inkstone case

Gyeongsang, or reading table for books or scrolls; originally used in temples for Buddhist sciptures

Boryo, or sofa-futon, usually placed above the firing hole of the ondol, or hypocaust system, which heated the floor

Jangchim, or square pillow to hold arm and elbow

Furniture

Traditional furniture was deeply dependent on two specific features of life in Korea in the past: first, that all activities in the home (meals, work, sleep) were held floor level, and second, that each room's function was adaptable, meaning a space could easily transit from acting as a study to being a bedroom or a dining place. For this reason, Korean furniture tends to be versatile, minimalist and compact. It is also typically all made of wood: as well as pine especially, paulownia and ginkgo, among others. Though nurturing an aesthetic of simplicity, Korean furniture crafters also possess great skills in metal fittings and lock patterns.

One of the most ubiquitous and still-used pieces of furniture is the **soban** 소반, or portable table. Meals were taken separately in traditional families, with married men eating at individual tables while younger people and women enjoyed their meals in another room— hence the need for many small, low and light tables. The selection of *soban* available feature differently shaped tops and legs: Tops can be round, square, octagonal or flower-shaped; the legs could be straight or in a dog or tiger shape.

The *soban* differ mainly by their functions— for preparing medicine, for writing, for serving alcohol, food or tea—which determined the shape. They are also distinguished by their regional features, such as *najuban* (the most simple), *haejuban* (the most delicately carved, though the weakest in structure) and the common *tongyeongban*.

A *soban* with a tray-shaped top, used for serving tea

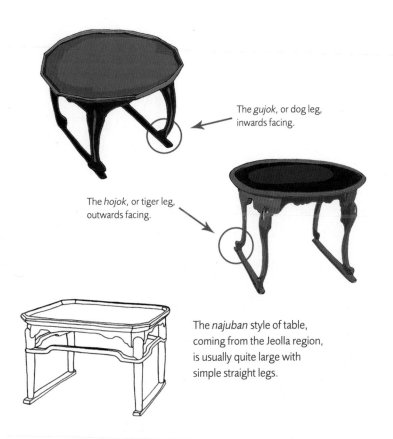

The *gujok*, or dog leg, inwards facing.

The *hojok*, or tiger leg, outwards facing.

The *najuban* style of table, coming from the Jeolla region, is usually quite large with simple straight legs.

The *haejuban* style, originating from the Hwanghae region in present-day North Korea, with its intricate *pangak* (openwork boards) on the side legs.

A **gyeongdae** ^{경대}, or vanity case used by ladies for their makeup, equipped with a mirror.

Bandaji ^{반닫이}, or chest with a hinged front flap; used for storing clothes, ritual items and sheets, with blankets and sleeping pads stored on top.

Mother-of-pearl, tortoiseshell, sharkskin and brass inlay could be used as decorations, like in this **gaegaesurijang** ^{개개수리장}, or chest safe; this kind of elaborately decorated chest was usually found in the room of the female elite, with men's furniture being simpler in design.

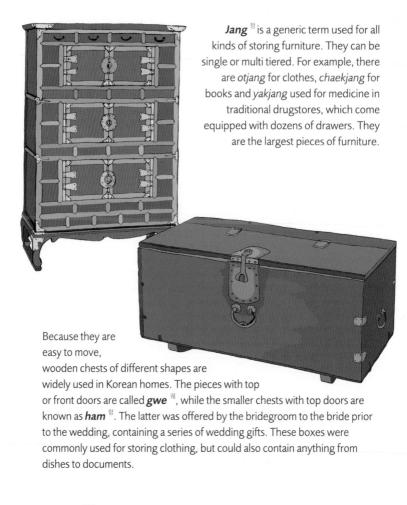

Jang ^장 is a generic term used for all kinds of storing furniture. They can be single or multi tiered. For example, there are *otjang* for clothes, *chaekjang* for books and *yakjang* used for medicine in traditional drugstores, which come equipped with dozens of drawers. They are the largest pieces of furniture.

Because they are easy to move, wooden chests of different shapes are widely used in Korean homes. The pieces with top or front doors are called ***gwe*** ^궤, while the smaller chests with top doors are known as ***ham*** ^함. The latter was offered by the bridegroom to the bride prior to the wedding, containing a series of wedding gifts. These boxes were commonly used for storing clothing, but could also contain anything from dishes to documents.

Mungap ^{문갑}, or a low stationery chest that is usually part of a matching set.

Palaces, Fortresses and Gardens

Although influenced by neighboring China, the Korean art of palaces, gardens and fortresses display Korean aesthetics at their best. The official monumental architecture of the past, complemented by its landscape design, embodied the ideology of the regime: a three-dimensional textbook of the ideal relations between humans and society, humans and nature, and humans and power. It also offers traces of Korea's unstable past.

Palaces

Capitals of old kingdoms of Korea left few traces of their palaces apart from minor archaeological remains, such as building foundations. It is in Seoul that the royal architecture can be best appreciated, displayed in palaces from the Joseon Dynasty (1392–1910). There were many main and sub-palaces in the capital, but the most significant ones that are still standing are the following:

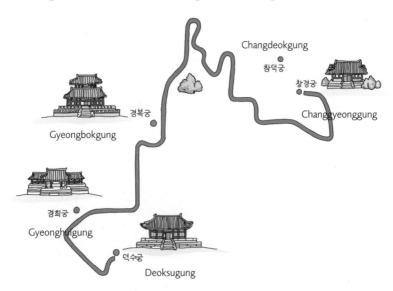

Changdeokgung
창덕궁
창경궁
Changgyeonggung
경복궁
Gyeongbokgung
경희궁
Gyeonghuigung
덕수궁
Deoksugung

Gyeongbokgung is behind Gwanghwamun, or Gate of Radiant Mutations, at the core of historic Seoul. Constructed in 1395, it was the central palace until being heavily damaged by a fire during the Japanese invasion of 1592. The structure was almost abandoned and left in ruin until the Prince Regent Heungseon Daewongun decided to rebuild it at the end of 19th century as a symbolic expression of the dynasty's power.

Changdeokgung is a secondary palace situated on the eastern side of the former, and has served as the residence of kings after each Japanese invasion.

Changgyeonggung is close to Changdeokgung and was used as an auxiliary palace for the king's parents, queen dowagers, etc.

Deoksugung is located in the center of city hall square. Built for princes, this smaller palace was used after the fire of Gyeongbokgung in 1592, as well as by the Emperor Gojong for a brief period after the assassination of Empress Myeongseong at the end of the 19th century.

Other secondary palaces included the **Gyeongheuigung** and **Unhyeongung**, among others.

The architecture of royal palaces from the Joseon era is deeply influenced by the Chinese tradition. The rectangular orientation of these structures includes smaller squares intertwined with larger yards that are linked by roofed corridors, a style that extended from the public spaces to the most private quarters. An expansive hall would usually open in the front (called *jeongjeon* and used for large ceremonies and receiving envoys), along with secondary offices for state administration around the sides. Moving further to the back of the palace, one begins to penetrate the private and sacred realm of the king's intimate living spaces: dining and banquet halls, the queen's and concubines' halls, kitchens, libraries, pavilions, ponds, gardens and the king's quarters.

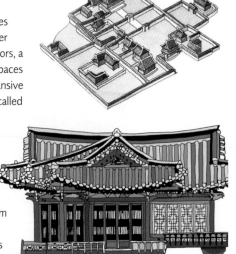

Gardens

Korean gardens are said to be different from their Chinese and Japanese counterparts in that their design often lets nature remain "as is" without attempting to control it too much. The Korean garden is at its best when set separately as a pleasure garden for the nobility to simultaneously enjoy nature, art and good company. A pavilion, pond and stream are necessary features, but they should each complement an existing natural structure or relief, not transform it. A perfect example can be found in the literati gardens of the Gwangju area (Jeolla region), such as **Soswaewon**. The model of all modern gardens, however, is perhaps the beautiful **Huwon**, or Rear garden (also known as Biwon, or Secret Garden)

behind Changdeokgung Palace. Kings, like the *yangban*, would come to their garden to enjoy drinking parties with *gisaeng* and concubines, as well as poetry composition in the pavilions, boating on the ponds and general contemplation around the grounds: Gardens were a microcosmic version of the wild for the elite, allowing them to nurture a romantic experience of nature.

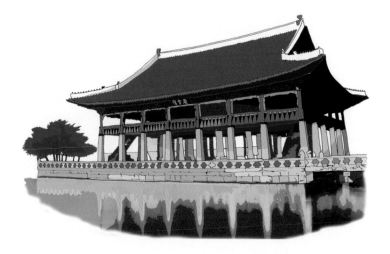

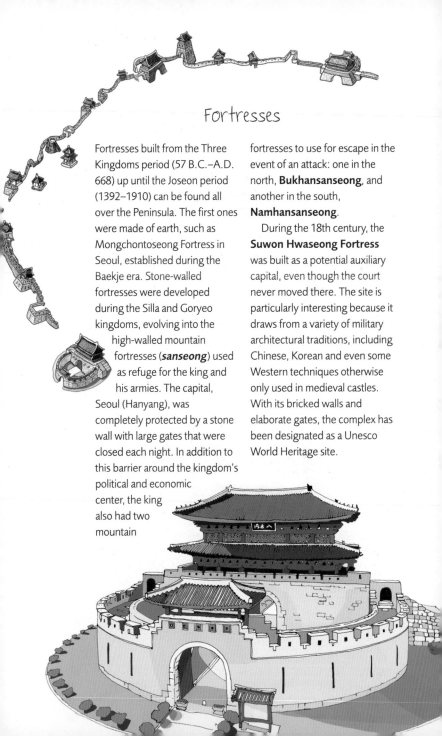

Fortresses

Fortresses built from the Three Kingdoms period (57 B.C.–A.D. 668) up until the Joseon period (1392–1910) can be found all over the Peninsula. The first ones were made of earth, such as Mongchontoseong Fortress in Seoul, established during the Baekje era. Stone-walled fortresses were developed during the Silla and Goryeo kingdoms, evolving into the high-walled mountain fortresses (**sanseong**) used as refuge for the king and his armies. The capital, Seoul (Hanyang), was completely protected by a stone wall with large gates that were closed each night. In addition to this barrier around the kingdom's political and economic center, the king also had two mountain fortresses to use for escape in the event of an attack: one in the north, **Bukhansanseong**, and another in the south, **Namhansanseong**.

During the 18th century, the **Suwon Hwaseong Fortress** was built as a potential auxiliary capital, even though the court never moved there. The site is particularly interesting because it draws from a variety of military architectural traditions, including Chinese, Korean and even some Western techniques otherwise only used in medieval castles. With its bricked walls and elaborate gates, the complex has been designated as a Unesco World Heritage site.

Spiritual

5

Religions

Korea is sometimes dubbed "Land of Spirits," and religion and spirituality still have a real importance in daily life. Half of the population is agnostic*, with the other half being distributed between Buddhists and Christians. But besides these large dominant religions, local beliefs and other schools of thought are still followed and worshipped, such as Confucianism, Taoism and Shamanism—there even are several indigenous religious sects!

* Note: Figures given here are official statistics from the Korean Statistical Information Service collected for 2007 (www.kosis.kr).

Catholicism

Catholicism was brought in Korea at the end of the 18th century by a group of Korean scholars who discovered it in China. It is the only case of this religion being propagated by local people themselves. Later, Western missionaries were sent to educate the believers, but were sought out and persecuted by the state soon thereafter. In Seoul, the church of Jeoldusan and the hill on which it stands serve as a memorial to the many martyrs, both Korean and foreign, who were persecuted there. At the end of the 19th century, Catholicism was given freedom of religion, and since then it has flourished, representing up to 20.6 percent of the practicing believers in Korea.

Protestantism

The Protestants arrived later than the Catholics, but their efforts to build hospitals and schools brought them a lot of followers, since they were associated with Western science and progress. Divided into many sects, as a group they represent 62 percent of the Christians in Korea. These high numbers have resulted in huge competition, forcing churches to promote themselves, which explains the prevalence of the strange red neon crosses in the country's nighttime cityscapes.

Buddhism

Buddhism was introduced to Korea during the Three Kingdoms era in the fourth century. From the beginning, Korean Buddhism tried to unify the different Buddhist traditions, creating a unique, syncretic version. Belonging to the Mahayana school, it is mostly represented in the *seon*, or zen, lineage, which has different orders (**Jogye** being the most powerful). Korean Buddhism counts around 10 million believers in Korea, or 43 percent of the people who identify with a specific religion. It was very powerful until the Goryeo Dynasty, but lost a lot of its influence during the Neo-Confucian Joseon Dynasty. By the end of the 19th century, it was overtaken, especially in urban environments, by the Christian faith.

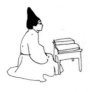

Confucianism

Confucianism gained wide popularity as the state ideology of the Joseon Dynasty. It had been introduced from China and was especially popular under its Neo-Confucian form developed in China during the 12th century by Zhu Xi (1130–1200). Although not exactly a religion, it is a system of thought that focuses on social relationships and the practice of virtue as taught by Confucius.

Seonggyungwan 성균관, established in Seoul in 1397, was the national college and shrine where Neo-Confucianism was taught and Confucian scholars' tablets were worshipped. Rituals are still held there regularly, though many families also perform them at home for their ancestors at least twice a year. Despite the commonality of these practices, only 0.42 percent of the people with a religion claim to be Confucianists. Seonggyungwan presents a structure that established the model for all *hyanggyo* 향교 (provincial Confucian schools) and *seowon* 서원 (private Confucian institutes).

First, a yard with a shrine to Confucius and major Confucian sages, and secondary shrines for other famous scholars' tablets. The second yard hosts the class pavilion and students' dormitories on each side. Other buildings include libraries, a canteen, ritual preparation halls, etc. Gingko trees were always planted in such schools as they are considered to be Confucius' tree.

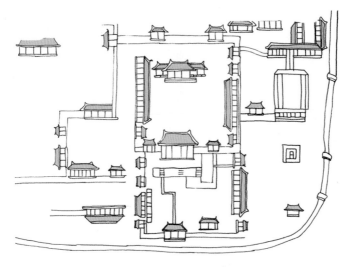

Seonggyungwan

Taoism

Taoism is not a religion in Korea per se; rather, it's a school of wisdom based on the writings of Chinese masters like Laozi (circa sixth century B.C.), which evolved into a popular form of worship and superstitions in China. In Korea, it infuses a lot of symbols and traditional thought in general, without having a formalized worship group.

Daejonggyo

Daejonggyo is a local religion based on the worship of Dangun, the mythical founder of Korea. It is said to have been active as an anti-Japanese organization during the colonization, having 3,766 followers as of 2007.

The Unification Church

Korea houses several indigenous
religions, one of which being the
Unification Church. It is best known in the
West under the name of its
charismatic leader Moon
Sun Myung—the Moon
sect—and has gained
fame for its huge wedding
ceremonies in stadiums.

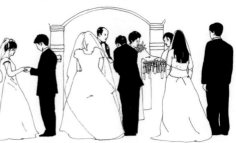

Cheondogyo

Cheondogyo is a religion that blends principles of
Confucianism, Buddhism and Taoism, founded by Choe
Je-u (1824–1864) in 1860 as Donghak, which was
renamed to Cheondogyo in 1905 by Son Byeong-heui
(1861–1922).It played an important role in independence
movements, and now has around 45,800 followers.

Jeungsangyo

Jeungsangyo is an indigenous religion founded
by Gang Il-sun (1871–1909) in 1902, mixing
different local traditions, such as Cheondogyo,
while putting a special emphasis on popular
shamanism. It represents only 0.14% of the
believers in Korea.

Won–Buddhism

Won-Buddhism is a syncretic,
local version of Buddhism
founded in the early 20th
century by Pak Chung-bin
(1891–1943). It represents
0.52 percent of believers.

Shamanism

Shamanism is said to be the oldest form of religion, and it is found in many regions around the world. In Korea, this tradition is still very much alive, although today's shamanism is very different from the times of the Three Kingdoms when shamans were more than simply priests—they also sometimes served as king or chief figures.

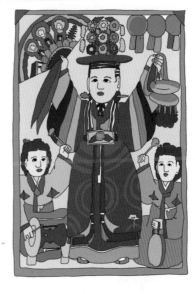

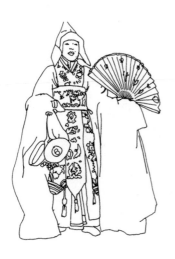

Shamanism is a belief system that incorporates spirits, nature (objects, trees, mountains, etc.) and human beings (souls). There are good and evil spirits that interact with human affairs, and the shaman plays a central role in communicating with these spirits, whose influence is crucial for human happiness. He or she is the mediator between humankind and the supernatural. The female shaman, nowadays the most common in Korea, is called a **mudang** 무당, whereas her male counterpart is called a **baksu** 박수 or baksu mudang.

There are two kinds of shaman in Korea. The southern style is more represented by those who inherit their vocations from their ancestors, and while those who have been chosen by the spirits are now more frequent in the north and in the Seoul area.

Shamans who inherit their powers (*seseupmu*) perform rituals and prayers and get in contact with the spiritual world, but they are not possessed by an actual spirit. They keep their own identity during the process. Their ceremonies are much calmer than the other style, with their dances being quieter and their music more elaborate.

There are three main reasons for a shamanist ritual: the welfare of the state or the community, healing or curing diseases caused by evil spirits and those trying to lead the deceased souls to the heavenly world and liberate human beings from their negative influence.

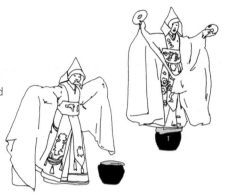

They are of two main types of rituals: simple prayers (*bison* 비손) offered by rubbing palms, or assimilation with the spirit in a state of ecstasy (**gut** 굿). For the latter, this specific spirit can be a deity of nature (mountain spirit, etc.) or a historical figure (general, king, etc.). During the act, the spirit descends upon the shaman's body and speaks through his or her voice. In this ecstatic ceremony, or *gut*, the music is led by hectic percussions, the dance is very dynamic (it went on to influence both folk and modern dance) and the shaman will wear one of his or her 15 or so costumes, depending on his or her leading spirit.

Divination and Geomancy

Like everywhere else in the world, divination—a revelation of the future, present and hidden conditions of the past—has been practiced since ancient times, and is still widely used today. Korea has its own traditions, even though they share universal or regional features inherited from Taoism and Chinese culture. They are intermixed with local folk beliefs and shamanism, meaning they can sometimes be difficult to separate from one another.

Jeom 점

Jeom is a word used to describe fortune-telling—all of the techniques used to explain the fate of someone and help them to avoid misfortune. There are many styles of *jeom* that are performed by different kinds of people, and since the practice is considered to be an occult science, there are no defined rules and it is difficult to describe precisely.

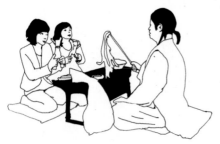

We can find three large sections of fortune-telling in Korea. The first one is comparable to Western astrology in that it is practiced by observing changes in natural objects such as the moon, stars, etc. The second is often called **cheolhak** 철학, a word that translates as "philosophy" and is the science of divination based on the **sajupalja** 사주팔자 theory. Able to be practiced by anybody who has the

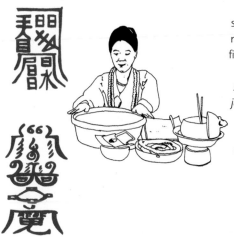

specific knowledge, it does not require special inspiration. This final detail is what differentiates it from the third kind, called *sinjeom*, which is practiced by *jeomjaengi*, or people who are possessed by a spirit or a god speaking through him or her about the client's fortune. The *jeomjaengi* may use objects such as rice, money, cards or sand to deliver this message and they are often, but not necessarily, also shamans.

Saju 사주

Saju is the theory of the Four Pillars, or the four elements which support the fate of a person: the year, month, day and hour of birth. These *saju* are written using two Chinese characters each, making eight characters, or *palja*. The *sajupalja* refers to a pension's fortune, including their character, appearance and profession, among other things. Examining the *saju* helps determine the best way to plan one's future and to avoid bad influences. Thus, it is still used today to find a propitious name for a child. It is also still a custom for a couple to exchange their *saju* documents before marriage to confirm that the pair is a good match as spouses.

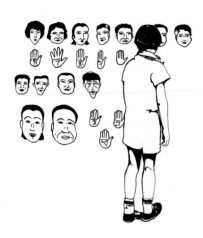

Gosa 고사

Gosa is not a divination ritual in itself, but it is one of the sacred rituals still widely practiced nowadays for bringing good fortune on any new undertaking. Originally, it was a family ritual performed by women for the house-protecting gods, especially during the 10th lunar month of the year as a way to pray for abundant harvest and peace for the family. It was eventually practiced on any occasion, and is now held when anything new is launched, such as a business, a building, a boat or a movie, even. *Gosa* is carried out using food and pure water offerings, and can be performed by anyone, though, people often ask a shaman to organize the event. A pig head is offered to the spirits, with money placed in the mouth to pray for success.

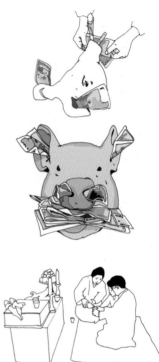

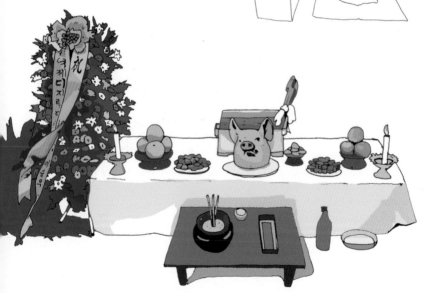

Pungsujiri 풍수지리

A specific tradition of geomancy has developed in Korea since at least the Goryeo times. Called *pungsujiri*, or the geography of winds and waters, it played a very important role in past dynasties, and is still in use nowadays for determining a propitious site for a building or tomb. It is based on the idea that the natural energies emitted by the topography have a decisive influence on our lives. Mother Earth, symbolized by mountains and water streams (*su*), when properly harmonized with heaven, can offer forth her energy or *gi* (seen in *pung*, the wind) and produce propitious sites called *myeongdang* where this energy flows and is stored. Specialists are called to either choose the appropriate site or fix the ominous one.

For the *myeongdang*, there should ideally be a mountain protecting the back of the place, as well as a "White Tiger Mountain," or *baekhosan*, on the west side and a "Blue Dragon Mountain," or *cheongnyongsan* on the east side. The site itself is on the *hyeol*, or "hole," where the energy emerges. It faces an open space protected by one or two hills. If possible, a water stream should flow to "drain" the bad energies. Seen on geomantic maps, the *myeongdang* look like half-cut onion. The Seoul historic center is a perfect illustration of that theory.

Folk Beliefs

Besides Buddhism and Christianity, Korea houses a broad spectrum of beliefs and religious movements. While Confucianism is a widely influential value system supported by rites and traditions without a supreme being, shamanism is not exactly a religion; rather, it represents practices and rituals that revolve around the relationship between the shaman and the spirits' world. It is based on different beliefs that take their roots in what Western cultures might consider an indigenous religion, or a loose body of religious conceptions and practices. The folk beliefs have been known to incorporate animism, or the belief that the universe is full of spirits and that some of them can protect us against evil spirits and bad luck. The difference between this "folk religion" and above mentioned religions is that folk religion can be practiced by anybody without the mediation of a priest or state apparatus. One trait that contrasts it with other systems, Confucianism especially, is that, most of the time, the worshippers are women.

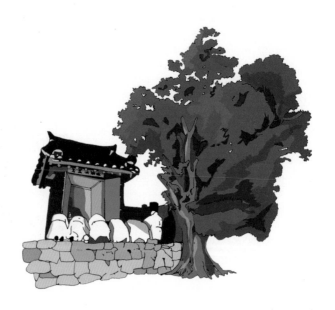

Birthmother Spirit

One of the most important gods of the domestic cult was the **Samsin Halmeoni** 삼신 할머니, or Grandmother Spirit. As a goddess of birth and child-rearing, her presence in the *anbang* (women's quarters) or delivery room was symbolized by a jar or sack filled with white rice. She received regular offerings of white rice, seaweed soup and clean water.

The House Spirit

Teoju 터주 was one of the house spirits, governing a family's property especially. It was symbolized by a totem of sorts, comprising a jar filled with rice and covered by woven straw (*teojugari*) that was placed in the courtyard. The item was supposed to give protection and prosperity to the household, and women were exclusively in charge of the informal offerings of rice and clean water.

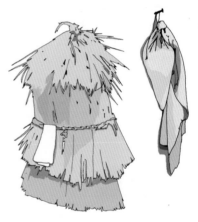

Also worshipped in the house was the *seongju* 성주, or protecting god of the house, symbolized by a piece of white paper hung on a ceiling beam.

Geumjul

Geumjul 금줄 was a straw rope woven left-wise and hung around objects or areas to mark them as sacred, meant to keep away impure spirits and beings. It was especially hung at the house gate when a baby was delivered. Objects were strung across the *geumjul* depending on the sex of the child: white paper or pine twigs for girls, red pepper for boys and charcoal for both. Only family members living in that house could enter during a 21-day period following the birth.

Geumjul was also tied on idols at a village's entrance, on public wells, on the houses of those who perform rituals and on shrines when a *dongje*, or village ritual, was held. It is used during *gosa*, *gut*, exorcisms and other sacrifices. It is also found on the *seonangdang*.

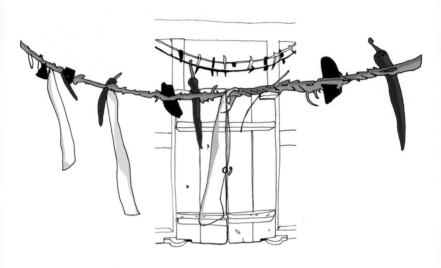

Village Shrine

Seonangdang 서낭당 is essentially a pile of stones at the edge of villages, on mountain passes or on roadsides used to symbolize a spirit to be worshipped. Along with the *jangseung* and *sotdae*, it marked the boundary between two villages and guarded against evil spirits. It was a place where travelers prayed for a safe journey by throwing a stone. It was

often paired with an old tree, considered to be a spirit (*sinsu* or *dangnamu*), where long pieces of cloth were hung by parents or merchants praying for prosperity. These were also often accompanied by a small shrine for village rites to be performed for the local god.

Buddhist Temple

Korean Buddhist temples are all different, but they share a common layout. Entering a temple in Korea represents much more than just a visit or a pilgrimage; it is entering the spiritual path leading to enlightenment. The site has been carefully chosen, often according to feng shui principles, among auspicious mountains. First, there must be a stream to cross: it symbolizes the passing of the river or sufferings on Buddha's raft (his teaching) to the "other side."

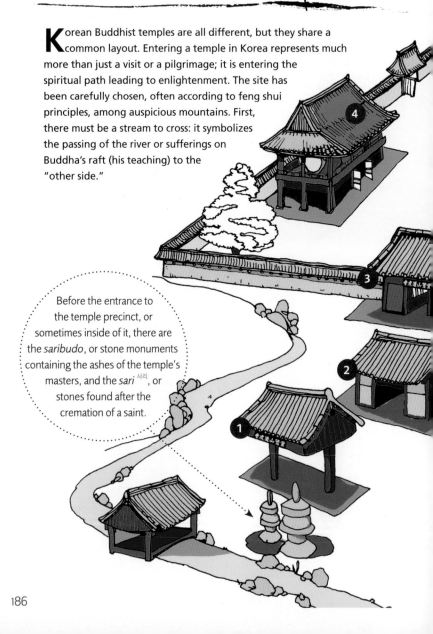

Before the entrance to the temple precinct, or sometimes inside of it, there are the *saribudo*, or stone monuments containing the ashes of the temple's masters, and the *sari* ^{사리}, or stones found after the cremation of a saint.

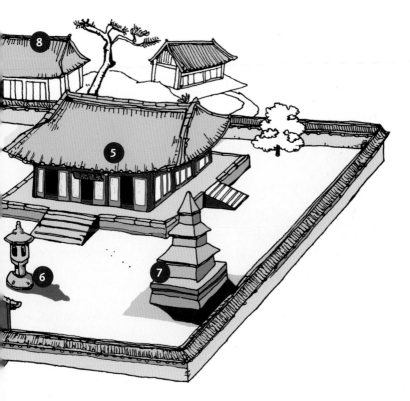

1 Iljumun 일주문

After the stream, we must pass under a
first gate, *iljumun*, the single pillar gate,
which has only two columns on one
single line, symbolizing the unification
of the pilgrim's body and spirit. By
entering the temple precinct, a person
begins to rid themselves of their duality.
His or her heart becomes as steady as the
Buddhist truth that holds the world, like the
gate that is held by a single line of pillars.

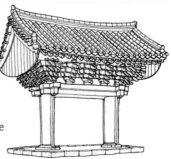

❷ cheonwangmun 천왕문

Next comes the *cheonwangmun* gate, the kings of heaven's gate. It hosts the statues of four fearsome-looking deities inherited from Hinduism. They are guardians of the four directions and prevent evil spirits from entering the temple.

❸ Burimun 불이문

Walking further into the temple grounds, one will cross the *burimun*, the non-dual gate representing the enlightenment state when there is no distinction between you and I, subject and object. Behind, there is often a hall-gate, either below or around which a visitor must go in order to enter the inner yard of the temple. Inside is where preaching and meditation session are held; the study of the dharma and the practice of meditation are requisites to attain buddhahood, similar to how one must go through this gate to join the main hall.

❹ Beomjonggak 범종각

On one side of the yard stands a belfry (*jonggak*), often on piles, which houses the four musical instruments that give rhythm to a monk's life: a big bronze bell (*beomjong*), a metallic gong (*unpan*), a huge drum (*beopgo*) and a wooden fish (*mogeo*). The fish is often found in Buddhist symbolism because, like wise men, fish never "sleep."

❺ Daeungjeon 대웅전

In the back of the yard stands the main hall dedicated to one of the Buddhas, and its name varies according to which one it represents. If Sakyamuni, the historical Buddha, is worshipped there, it is called *daeungjeon*. If there are relics of the Buddha kept in the temple, this hall doesn't have any statue.

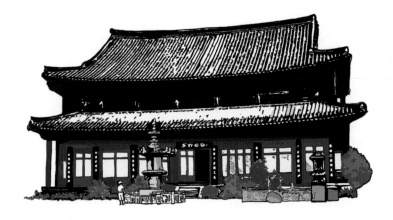

6 Seokdeung 석등 7 Seoktap 석탑

A stone lantern (*seokdeung*) usually stands in the front, as well as a stone stupa or pagoda (*seoktap*) with an odd number of stairs (3, 5, 7, etc.). This *tap* (tower) contains saints' relics, sacred scriptures or other holy objects.

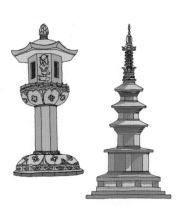

Around the main hall are a series of secondary halls that often receive a very popular cult. **Gwaneumjeon** is dedicated to the bodhisattva of compassion, known as Avalokitesvara, or Gwanseeum in Korean. **Jijangjeon** is dedicated to Ksitigarbha (known as Jijang in Korean), the bodhisattva that intercedes with the 10 kings or judges of the inferior world to save the damned soul. **Nahanjeon** houses the 16 enlightened Buddha's disciples, the Arhats.

8 Samsingak 삼신각

The *samsingak* hall houses three local shamanist deities: the mountain spirit, *sansin*, often depicted with a tiger; Samsin Halmeoni; and the Great Bear constellation (Chilseong).

Statues of Buddha

There are many types of Buddhist statues (*bulsang*) in Korea, and each of them is unique to a specific deity, hence being easily recognizable for the worshippers. They differ according to their posture, position, clothing, hand gestures and the objects or attributes with which they are depicted. Here are some tips for making your way around a Buddhist temple.

Posture

There are three basic postures possible for Buddhas in Korea: standing (a posture symbolizing the spread of Buddhism, popular during the introduction of the religion, the Three Kingdoms era), reclining (showing the historic Buddha Sakyamuni attaining nirvana, rare in Korea) and sitting cross-legged, or *gyeolgabujwa*, the most popular from the Silla era. Statues presenting other positions are not ones of Buddhas, but of different deities such as guardians or of bodhisattvas (**bosal** in Korean), holy people on their way to enlightenment who decided to help other beings.

Hand gestures

Hand gestures (*mudra* in sanskrit, *suin* in Korean) are a very important way of recognizing each Buddhist deity. Some are shared by different buddhas, whereas others are particular to specific ones. The historic Sakyamuni Buddha (Seokgayeorae) has four different possible gestures in Korean temples: *hangmachokjiin*, *seonjeongin*, *simuoein* and *jeonbeopryunin*.

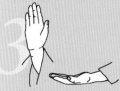

Hangmachokjiin is the most common gesture: Buddha, while attaining enlightenment under the boddhi tree, is touching the soil with his right hand to repeal the temptations of the devil and to call the earth as a witness. This gesture can also be performed in Korea by Amitabha (Amitabul) and Bhaisajyaguru (Yaksayeorae).

Seonjeongin is another typical gesture of the meditating Sakyamuni during the seven days following his enlightenment: both hands on his crossed legs, palms upward, one sitting on top of the other one.

Simuoein is a popular gesture where one hand is held straight, palm facing the front, repelling fear and suffering. It is often used in standing statues, and in Korea can also be associated with other forms of Buddhas and bodhisattvas.

Jeonbeopryunin is a beautiful gesture where the hands symbolize the Wheel of the Law (or Teaching) that Sakyamuni Buddha started to turn with his first sermon in the deer park.

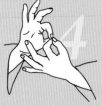

Jigwonin is the typical and unique gesture of Vairocana Buddha (Birojanabul in Korean), the metaphysical buddha embodying the Buddhist law and truth, and filling the world with the light of understanding. One hand's fingers grasp the index finger of the other one: it symbolizes that the Buddha and the masses are one.

Buddha statues are also recognizable according to other special attributes. Buddhas have distinct hair styles (*sobal*, meaning shaved, or *nabal*, meaning curled), whereas most bodhisattvas wear crowns. All Buddhas have a head protuberance called *yukgye*, a symbol of their wisdom. They also have a "white hair" placed in between their eyebrows called a *baekho*.

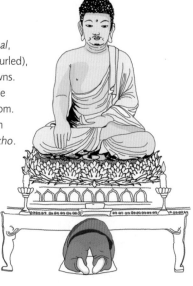

The different deities also have special objects: All of Buddha's statues are situated on a lotus pedestal (*yeonhwajwa*)—a symbol of purity. The very popular bodhisattva Avalokitesvara (**Gwanseeum** 관세음 or **Gwaneum** 관음 in Korea) usually holds a lotus flower (*yeonkkot*, sometimes in a bottle) or a bottle (*subyeong*) to offer lustrous water to the Buddha that he or she is attending (Amitabha or Sakyamuni). Other noticeable objects are a nimbus (*gwangbae*, in their back), Wheel of Law (Beopryun, especially held by Jijangbosal) and a medicine box for **Yaksayeorae** 약사여래,

the healing Buddha of the sufferings of this world.

Maitreya (**Mireukbosal** 미륵보살) is the bodhisattva of the future, a very popular form in Korea. It was often represented in a seated position during the Three Kingdoms era, with one leg crossed over the knee of the other leg and one hand touching his cheek in an elegant posture of meditation. Mireuk can also be a Buddha, in which cases his representations are completely different.

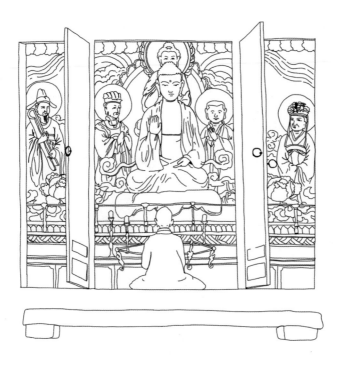

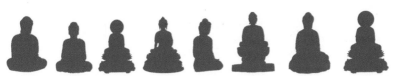

There are other types of Buddhist statues in Korea: different bodhisattvas (**Jijang**, or Ksitigarbha, interceding for the dead souls in hell amid the Ten Infernal Kings, or Siwang), the 16 or 18 of Sakyamuni's disciples called **Nahan** or Arhat, various guardians (Four Heavenly Kings, or Sacheonwang; *inwang*; *sinjang*, or generals, etc.) and rock surface carvings (*maaebul*), among others.

Buddha's Birthday

Buddha's Birthday, commemorated in May every year, is one of the most colorful and joyful events of the Korean calendar. Celebrated in every temple all around the country, the festivities span several days and are marked by hanging seas of bright lanterns and holding parades in major towns one week before the date of the birthday.

Traditionally, the historical Buddha Siddhartha Gautama is said to be born on the eighth day of the fourth lunar month of the year in 624 B.C. in Nepal. In 1956, to end long debates concerning the exact date and year of his birth, an international Buddhist convention was held and it was determined that the Buddha had been born 2,500 years earlier, and it was decided that it would be celebrated on 15 May following the solar calendar. Korea, however, still follows the lunar date, which falls on a different day of the solar calendar every year.

There are multiple names that have been created for this festival: **Seokgatansinil** ^{석가탄신일} (meaning "Buddha's birthday" in Sino-Korean), **Bucheonimosinnal** ^{부처님오신날} (the same meaning in pure Korean), and **Chopail** ^{초파일} (referring to the date in Sino-Korean, this is the traditional name). We also can refer to it as **Yeondeung Chukje** ^{연등축제}, or Lotus Lantern Festival, which is its main feature. Thousands of paper lanterns of different shapes and colors are hung in the streets and temples.

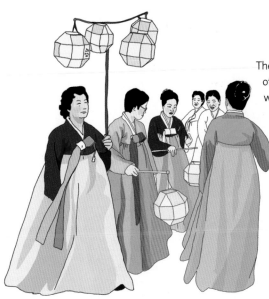

The Buddha came to this world of sufferings to "enlighten" us with his teaching, bringing light to this world of darkness and ignorance. Celebrating Buddha's birthday and offering lanterns is a way to thank the Buddha for this symbolic enlightenment that can free us from all pain.

The tradition dates back to the Goyeo Dynasty (918–1392) when it was called *yeondeunghoe*, *yeondeung* meaning "lantern." During the Joseon Dynasty (1392–1910), children used to go around the neighborhood playing drums and singing songs to receive rice or pears, which would be used to buy the materials to make the lanterns. Then they would hang them in the yard on a string attached between two decorated poles.

This practice became very popular during the Joseon Dynasty, as Chopail was the only night when it was permitted to circulate in the streets after the curfew. It is now a national holiday, and since 1996 it has been called Yeondeung Chukje, or Lotus Lantern Festival. Among the festivities is a long parade from Dongdaemun Gate to Jogyesa Temple in downtown Seoul. Bongeunsa Temple in Seoul's Gangnam area is another popular place to witness the festival in the nation's capital.

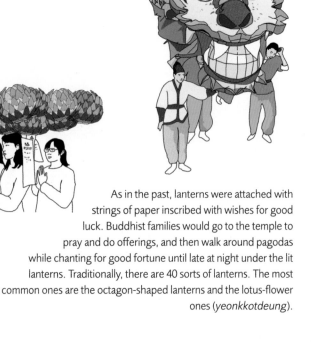

As in the past, lanterns were attached with strings of paper inscribed with wishes for good luck. Buddhist families would go to the temple to pray and do offerings, and then walk around pagodas while chanting for good fortune until late at night under the lit lanterns. Traditionally, there are 40 sorts of lanterns. The most common ones are the octagon-shaped lanterns and the lotus-flower ones (*yeonkkotdeung*).

Supernatural Beings

Korea has a set of imaginary animals and supernatural beings that you are going to encounter everywhere in the country—at least, in representations! Although some of them are no longer part of a living tradition, they are still alive in the collective Korean imagination. Some have Japanese or Chinese counterparts, while others are purely Korean inventions.

Haechi 해치, or a mythical unicorn-lion

Haechi or *haetae* is a lion-shaped imaginary animal with large, round eyes and a matching nose, overshot jaws and a horn on its head. They are sensitive to violent change and therefore able to ward off disasters and injustice. *Haetae* were typically placed in front of buildings, especially royal palaces, to protect them from fires. They were also believed to be able to judge the officials entering the palace, capable of deciphering the corrupt ones. These creatures were also represented on high officials' attire and as *japsang* on eaves.

Japsang 잡상

Japsang are animal- or human-shaped clay sculptures placed on the top of eaves, believed to ward off fire and other disasters from the building. We mainly find them on royal and Buddhist buildings.

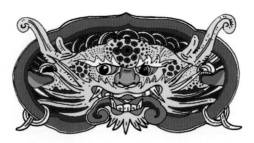

Dokkaebi 도깨비, a Korean Goblin

Whereas ghosts (*guisin*) are spirits of the deceased humans coming back among the living, *dokkaebi* are transformed spirits of inanimate objects left over by people. They look like grotesque dwarves perched on one leg, with a horn at the summit of their heads. They also hold clubs called *bangmangi*, which were used as a magic wand. Unlike their Japanese cousins the *oni* goblins, they are not harmful; they just play tricks on bad people while rewarding good people. They also love playing games, such as *ssireum*.

Sotdae 솟대

Similar to *jangseung*, *sotdae* are poles posted at the entrance of villages. They were topped by wooden bird sculptures, said to be ducks. As a migratory bird leaving half of the year for unknown territories, these birds were thought to travel to the land of the dead. They became a symbol of an intermediary messenger between humankind and the spiritual world. Being also between Earth, water and sky, they were a perfect medium for carrying prayers to gods, and their regular return with spring each year made them a good symbol for the planting season. For this reason, wishes for good harvests were also addressed to the *sotdae*, along with prayers for protection.

Yong 용

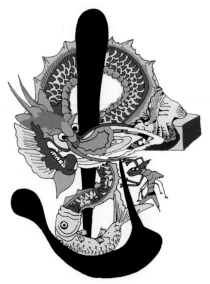

The dragon (*yong*) is seemingly a rather universal symbol, but we should be careful to separate its appearance from its function. In fact, there are two different types of dragons in Korea: the dangerous, monstrous beast living in ponds or in the sea, such as a huge snake trying to bother human beings, and the positive, aerial dragon, king of ocean and a symbol of eternity and power.

Bonghwang 봉황

In English, it is often called "the Chinese phoenix," although it is slightly different from the Western phoenix; this imaginary bird is made of the original couple of the male *bong* and the female *hwang*. Whereas the dragon represented the emperor, the *bonghwang* symbolized the empress, as well as acting as a symbol of loyalty, honesty and prosperous times. The immortal bird is an emblem of power in Korea, representing the king's power in the past and is now used as the presidential symbol.

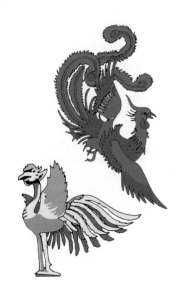

Dolhareubang 돌하르방

This supernatural being is only found on Jeju-do Island, although it resembles sculptures found in other Pacific islands. Its name means "stone grandfather" in the Jeju dialect. This volcanic stone man has two arms placed on his stomach, huge round eyes, a big nose and a cone-shaped hat. Its phallic appearance is obvious and, even now, brides come to rub its nose to conceive a son. A *dolhareubang* was originally placed in front of official buildings and fortresses as a boundary post, and also to protect these places from evils and injustice.

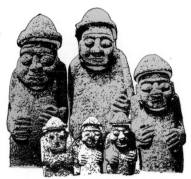

Jangseung 장승

Jangseung, or totem poles, are tree trunks sculpted with a human-looking, grimacing face with a crown-like hat, a flat nose, enormous eyes and an open mouth. They usually came as a pair—one depicting the king of the heavenly realm, while the other portraying the queen of the underground realm—but could also be set alone or as a group. Despite their fierce appearance, they are not monsters; they are guardians warding off evils and disasters from human settlements. They were usually placed at the entrance of villages or on roads as guideposts to mark the boundaries between two towns. Passing travelers would pay homage to them for their protection on the road.

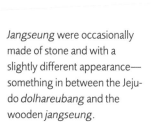

Jangseung were occasionally made of stone and with a slightly different appearance—something in between the Jeju-do *dolhareubang* and the wooden *jangseung*.

Royal Tombs

In a country that places such importance on the worship of ancestors, it is not surprising that tombs have a special significance in Korean culture. Royal tombs (*wangneung* 왕릉) in particular were not only the last abode of dead monarchs; they were also places to hold regular rituals in order to signify the continuity of the lineage and pray for the prosperity of the country. Besides the grave itself, they included a park with many buildings for the keepers, ritual vessels and kitchens. The royal tombs of the Joseon era were inscribed on the UNESCO World Heritage list in 2009. Since they were the model after which ordinary people's graves were designed, let's start with them.

Joseon royal tombs

The royal tombs present a structure that has remained unchanged since the beginning of the Joseon Dynasty. They were constructed in the shape of a tumulus, built on low hills that were located in an auspicious site according to feng shui. The sites themselves are preceded by buildings for preparing the rites. On the slope, there are three stone terrace levels: first, on each side of the central alley is a stone statue of a soldier, called *mugwanseok* (or *muinseok*) and representing the military class of the aristocracy (*yangban* class).

On the next level are the two statues of literati or scholars called

mungwanseok (or *muninseok*) representing the other class of the aristocracy. Behind these four statues, or sometimes on the next level, one can see horse statues called *seokma*. In the center of the alley, between the statues, is a stone lantern borrowed from Buddhist architecture, and behind it a stone table used for ritual offerings. At the same depth as the table one can see two stone posts (*mangjuseok*) indicating the threshold of the grave itself.

The grave is composed of a small earth tumulus in the center, covered with short grass and surrounded by a short wall made of 12 granite panels. During the Silla kingdom, these panels could be engraved with the zodiac signs. In addition to the stone wall, which symbolizes the sun and the sky, the tumulus is also surrounded by a stone fence. Two *seokyang* (stone rams) and two *seokho* (stone tigers) guard the tomb against evil spirits, and are surrounded by a three-paneled stone wall.

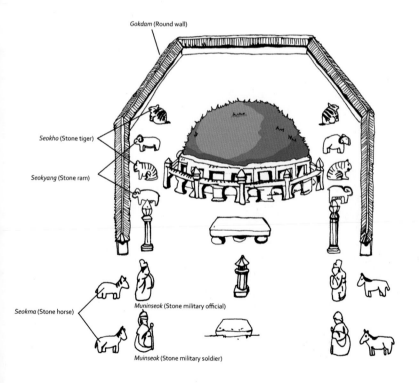

Gokdam (Round wall)

Seokho (Stone tiger)

Seokyang (Stone ram)

Seokma (Stone horse)

Muninseok (Stone military official)

Muinseok (Stone military soldier)

Silla and Goryeo eras

Before Joseon, during Goryeo times, the funeral styles were very similar to those of the Unified Silla era. The stone statues of *muinseok*, or soldiers, were not yet present; only the scholar ones could be found. Since the capital of Goryeo was located in present-day North Korea, this style is more difficult to observe, but there are a few tombs on Ganghwa-do Island where the court took refuge for almost a century.

In fact, the Joseon tomb style dates back to the Silla kingdom, and especially the Unified Silla; they included a tumulus, the 12-stone paneled wall and the central alley leading to the grave with the statues on each side. The best example of the late Silla style of tomb—the one that was to later become the model for those of the royal family—can be found in the

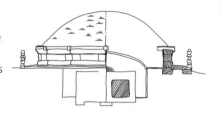

Gwaeneung tomb in Gyeongju (the suffix -**neung** is usually attached to the name of a royal tomb). This grave has both a wall that is engraved with the zodiac signs and a series of large stone statues, among which are bearded and curly-haired soldiers who are thought to be mercenaries coming from the Middle East.

The *mungwanseok* statue represents a scholar dressed in the traditional style inherited from China. He wears a hat called a *bokdu*, a Chinese coat, the official belt indicating his rank and in his hands he holds a tablet called *hol* that was made in different materials depending on the rank, and which symbolized the royal mandate (in ancient China, this tablet was known to communicate imperial orders).

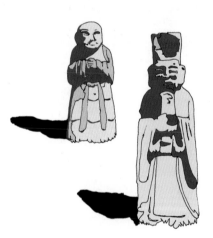

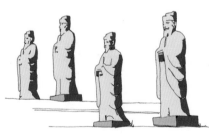

The tombs of the members of the two orders of nobility (*yangban*) shared a similar structure with those tombs of the royal family. They didn't have any ritual building, however, and there were neither stone tigers nor rams nor horses, and the human statues were limited to two literati or soldiers, depending on the class. The 12 granite panels and the fence were also used on royal tombs exclusively. Even nowadays, people who consider themselves as "nobility" or "scholars" build this kind of grave, while "commoners" prefer simple earthen tumulus.

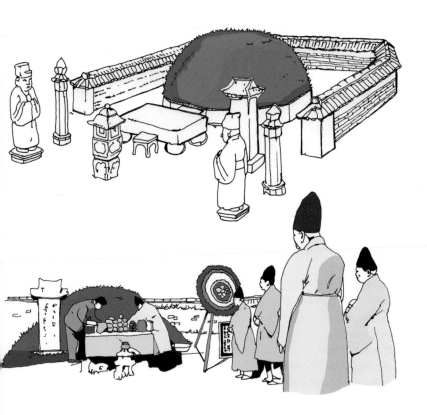

Index

A

Agungi 아궁이 25
Ajaeng 아쟁 117
Ajeossi 아저씨 10, 12-13
Ajumma 아줌마 12-13, 23, 51
Amitabul 아미타불 191
Anbang 안방 155, 183
Anju 안주 62-63, 74-75
Apateu danji 아파트 단지 32, 35, 46
"Arirang" 아리랑 121

B

Baduk 바둑 87, 158
Baechu 배추 65, 67
Baegeui Minjok 백의 민족 141
Baegil 백일 10
Baekban 백반 58
Baek kimchi 백김치 67
Baekhosan 백호산 181
Baekja 백자 106
Baekje 백제 167
Baekseju 백세주 73
Baekseolgi 백설기 59
Baji 바지 139
Baksu 박수 175
Banchan 반찬 18-19, 56, 64
Bang 방 122, 155
Bap 밥 18
Bapsang 밥상 19
Beomjonggak 범종각 188
Beondegi 번데기 61
Beonji 번지 46

Bibim naengmyeon 비빔냉면 57
Bibimbap 비빔밥 56
Billa 빌라 34
Bindaetteok 빈대떡 57
Birojanabul 비로자나불 191
Biwon 비원 166
Bojagi 보자기 114, 153
Bokbunja 복분자 73
Bonghwang 봉황 83, 200
Bori 보리 18
Bosal 보살 190
Beoseon 버선 135, 139
Bossam 보쌈 67
Buchae 부채 113
Bucheonimosinnal 부처님오신날 194
Buchimgae 부침개 63
Buk 북 119
Bulgama 불가마 31
Bulgogi 불고기 59
Burimun 불이문 188
Bulsang 불상 190
Buncheong 분청 104, 106
But 붓 101
Byeongpung 병풍 159
Byeoru 벼루 101

C

Chaekjang 책장 163
Changdeokgung 창덕궁 164-166
Changgyeonggung 창경궁 164-165
Chapssaltteok 찹쌀떡 23
Charye 차례 44, 79

Cheolhak 철학 178
Cheondogyo 천도교 174
Cheonggukjang 청국장 71
Cheonghwa-baekja 청화백자 106
Cheongja 청자 105
Cheongnyongsan 청룡산 181
Cheonwangmun 천왕문 188
Chima 치마 134
Chogajib 초가집 36, 157
Chonggak kimchi 총각 김치 67
Chuimsae 추임새 120
Chuseok 추석 17, 44, 59, 78-79, 110, 112

D

Daegeum 대금 117
Daejonggyo 대종교 173
Daeri unjeon 대리 운전 75
Daeungjeon 대웅전 188
Dan 단 148
Dancheong 단청 113
Dangun 단군 78, 173
Dano 단오 78-79, 88
Deoksugung 덕수궁 164-165
Deungsan 등산 13
Dimchae 딤채 71
-Do (island) −도 78, 200, 204
Dobok 도복 148
Doenjang 된장 58, 69, 71
(Ingam) dojang (인감) 도장 50
Dok 독 64, 71, 108
Dokkaebi 도깨비 114, 198
Dol 돌 10
Dolhareubang 돌하르방 200-201
Dolsot 돌솥 56
-Dong -동 22, 46
Dongchimi 동치미 67
Dongdongju 동동주 57, 73

Dubu 두부 62, 71, 151
Durumagi 두루마기 139
Dutch pay 더치 페이 74

E

Eum-yang 음−양 80

G

Galbi 갈비 59
Galbitang 갈비탕 58
Gama 가마 39, 108
Gamasot 가마솥 151
Gamjajeon 감자전 57
Ganggangsullae 강강술래 112
Ganjang 간장 69-70
Gawi, bawi, bo 가위, 바위, 보 86
Gayageum 가야금 117
Gayo 가요 121-122
Geobukseon 거북선 83
Geomungo 거문고 117
Geonbae 건배 74
Geumjul 금줄 183-184
Gi 기 148
Gimjang 김장 68
Gisaeng 기생 109, 158, 166
Giwa 기와 36, 114
Gochujang 고추장 69, 71
Goguryeo 고구려 114, 147
Gohyang 고향 79
Golbaengi 골뱅이 62
Gomusin 고무신 140, 150
Gopchang 곱창 63
Goryeo 고려 104-105, 171, 204
Gosa 고사 59, 180, 184
Go-stop 고스톱 88
-Gu −구 46
Gugak 국악 120

Guk 국 18-19, 58
-Gung 궁 83, 164-166
Gunghap 궁합 38, 40
Gun-mandu 군만두 58
Gut 굿 117, 184
Kkwaenggwari 꽹과리 119
Gwanseeum (Gwaneum) 관세음 (관음) 192
Gwanghwamun 광화문 83, 165
Guisin 귀신 198
Gyeolhonsik 결혼식 41
Gyeongbokgung 경복궁 83, 164-165
Gyeongheuigung 경희궁 164-165

H

Haechi 해치 49, 83
Haegeum 해금 117
Haejangguk 해장국 75
Haetae 해태 197
Haksaeng 학생 11
Hallyu 한류 122
Halmeoni 할머니 10, 13, 183, 189
Hanbok 한복 110, 134-135, 141
Hangari 항아리 108
Hangeul 한글 78, 84, 90, 92-93, 102, 156
Hanjeongsik 한정식 18
Hanji 한지 101
Hanok 한옥 24, 32, 37, 154-155
Hansik (holiday) 한식 44, 77, 79
Hanyang 한양 167
Harabeoji 할아버지 13
Hoesawon 회사원 12
Hojok 호족 161
Horangi 호랑이 82
Hot bar 핫바 60
Hunmin Jeongeum 훈민정음 92
Huwon 후원 166

Hwangap 환갑 13
Hwatu 화투 88
Hyanggyo 향교 172
Hyeong 형 10
Hyugesil 휴게실 28

I

Ibul 이불 25, 27
Ilcha, icha, etc. 일차, 이차 등 75
Iljumun 일주문 187
Injeolmi 인절미 59

J

Jagi 자기 105, 114
Jang 장 69
Jangdokdae 장독대 64, 69
Janggu 장구 119
Jangnye/Jangnyesik 장례(식) 42
Jangseung 장승 184, 199, 201
Jeogori 저고리 134-135, 139
Jeol (bow) 절 17
Jeom 점 178
Jeomjaengi 점쟁이 179
Jeon 전 57, 63
Jeongol 전골 58
Jeongsik 정식 58
Jesa 제사 42, 44
Jige 지게 51, 152
Jijang/Jijangjeon 지장(전) 189, 193
Jjigae 찌개 58, 71
Jjimjilbang 찜질방 28, 31
Jjin- 찐– 58
Jokbal 족발 63
Jongmyo 종묘 94-96, 116, 118
Jongmyo Jerye 종묘 제례 94, 96
Joseon 조선 94-96, 164-167, 202-203

Jueui 주의 45

K

Kan 칸 56
Kimchi 김치 13, 34, 58-59, 62, 64-65, 67-69, 71, 104, 108
Kkakdugi 깍두기 67
Kong 콩 69
Kongnamulguk 콩나물국 69
K-pop 케이팝 122

M

Madang 마당 120
Maesilju 매실주 73
Maetdol 맷돌 151
Makgeolli 막걸리 57, 63, 73
Mandu 만두 58
Maru 마루 155
Meju 메주 70-71
Meok 먹 101
Minbak 민박 24, 27
Minhwa 민화 123, 125, 128-130
Minyo 민요 121
Mireuk (bosal) 미륵 (보살) 192
Mobeom taxi 모범 택시 49
Mogyoktang 목욕탕 28, 31
Mongchon Toseong 몽촌 토성 167
Mudang 무당 175
Mudeom 무덤 42
Mugunghwa 무궁화 81
Mul kimchi 물김치 67
Mul-naengmyeon 물냉면 57
Munja messaeji 문자 메세지 53
Munjado 문자도 131
Myeolchi 멸치 63

N

Nabak 나박 67
Naengmyeon 냉면 57, 67
Nahan/Nahanjeon 나한(전) 189, 193
-*Neung* 능 202, 204
Nongak 농악 110, 118, 120
Noraebang 노래방 75
Norigae 노리개 135
Nuna 누나 10

O

Obang ohaeng 오방 오행 19
Odeng 오뎅 60-61
Ogokbap 오곡밥 18
Oiljang 오일장 23
Oisobagi 오이소박이 67
Ojingeo 오징어 63
Oncheon 온천 31
Ondol 온돌 25, 151, 159
Onggi 옹기 71, 104, 108

P

Pajeon 파전 57, 63
Palja 팔자 179
Pansori 판소리 120
Pension 펜션 24, 26, 37
Podaegi 포대기 52
Pojangmacha 포장마차 60, 62-63
Ppongjjak 뽕짝 122
Poomsae 품새 148
Pungsujiri 풍수지리 181

R

Room salon 룸 살롱 75

S

Saemaeul Undong 새마을 운동 157

Saeng- 생– 59

Sagunja 사군자 126

Saju 사주 38, 179

Salpurichum 살풀이춤 111

Samgyetang 삼계탕 57-58, 67

Samonim 사모님 12

Samsin Halmeoni 삼신 할머니 183

Samullori 사물놀이 119-120

Sang 상 19

Sangcharim 상차림 19

Sanseong 산성 167

Sansin 산신 189

Sanso 산소 42

Sansuhwa 산수화 123-124

Sarang-bang/-chae 사랑방/–채 101, 155, 158-159

Saribudo 사리부도 186

Sebae 세배 17, 79

(King) Sejong 세종대왕 78, 83-84, 90, 92, 95

Seokgatansinil 석가탄신일 194

Seokgayeorae 석가여래 191

Seollal 설날 17, 44, 77, 79, 85-86

Seolleongtang 설렁탕 58

Seon 선 171

Seonbi 선비 159

Seonggyungwan 성균관 172

Seowon 서원 84, 172

Siksa 식사 18, 56, 59

Silla 신라 38, 105, 147, 167, 190, 203-204

Sillang 신랑 38

Sin Saimdang 신 사임당 125

Sinbu 신부 38

Sinju 신주 43

Sipjangsaengdo 십장생도 129

Siru 시루 108

Soban 소반 19, 158, 160

Soju 소주 11, 60, 63, 72-76

Somaek 소맥 76

Songpyeon 송편 59

Soswaewon 소쇄원 166

Sot 솥 151

Sotdae 솟대 184, 199

Ssireum 씨름 149, 198

Subak 수박 147

Sundae 순대 61

Sura 수라 18

Sutgarak 숫가락 19

Suwon Hwaseong 수원 화성 167

Suyuk 수육 57, 67

T

Taegeuk 태극 80, 81, 113

Taegeukgi 태극기 80

Taekkyeon 택견 147-148

Taekwondo 태권도 147-148

Talchum 탈춤 111

Tang 탕 58

Tap 탑 189

Teuroteu (trot) 트로트 122

T-money 티머니 48

Toegye 퇴계 84

Togi 토기 105

Ttaemiri 때밀이 30, 51

Tteok 떡 59

Tteokbokki 떡볶이 59, 61

Tuigim 튀김 61

W

Wolse 월세 34

Y

Yak 약 45

Yaksayeorae 약사여래 191-192

Yangban 양반 82, 138, 142, 166, 202, 205

Yangnyeom 양념 59

Yeogwan 여관 27

Yeoinsuk 여인숙 27

Yeondeung (chukje) 연등 (축제) 194-196

Yeonkkot (deung) 연꽃(등) 192, 196

Yi Hwang 이황 84

Yi I 이이 84

Yi Sun-sin 이순신 83

Yo 요 25, 27

Yong 용 199

Yukhoe 육회 56

Yut 윷 86

Credits

Publisher	Kim Hyung-geun
Writer	Benjamin Joinau
Illustrator	Elodie Dornand de Rouville
Editor	Kim Eugene, Jung Young-kyoung
Copy Editor	Jaime Stief
Proofreader	Lee Kye-hyun
Designer	Son Hong-kyeong